A SCULPTOR'S RECORD

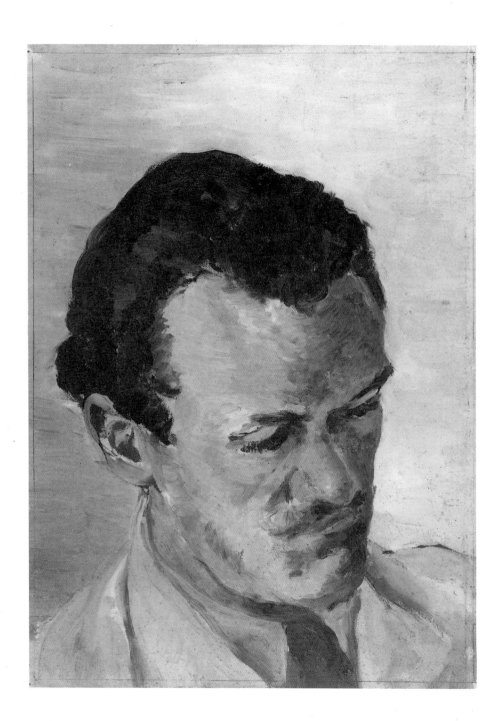

ALASTAIR GRIEVE

Robert Adams
1917-1984
A SCULPTOR'S RECORD

A Catalogue of the Material in the Tate Gallery Archive

Tate Gallery

cover: 'Collage Two' [n.d.], TGA 8421.2.2
frontispiece: 'Self-Portrait' c.1946, TGA 8421.8

ISBN 1 85437 107 X

Published by order of the Trustees 1992
© Tate Gallery 1992 All rights reserved
Published by Tate Gallery Publications,
Millbank, London SW1P 4RG
Designed by Caroline Johnston
Photography of Tate Gallery Archive material by
Tate Gallery Photographic Department
Typeset by Status Graphics, London
Printed and bound in Great Britain by
The Hillingdon Press, Uxbridge, Middlesex

Contents

7 *Foreword*

9 *Author's Note*

11 *Acknowledgments*

13 *Robert Adams*

21 *Catalogue*

 Sketchbooks and Studies [22]

 Records of Work [60]

 Collages [61]

 Maquettes and Three-Dimensional Objects [63]

 Documents and Self-Portrait [66]

67 *Chronology*

69 *Bibliography*

70 *Summary Listing of Contents*

Foreword

As one of the acclaimed young sculptors who represented Great Britain at the 1952 Venice Biennale, Robert Adams acquired an international reputation at an early stage in his career. He continued to be exhibited worldwide and received numerous private and public commissions both at home and abroad. He created sculpture of rare distinction and belonged to that generation of British artists to whom abstraction was at once a voyage of discovery and a rigorous discipline. His finely tuned, perhaps reticent sense of poetry seems unjustly neglected today and the purpose of this book is to bring together and make more widely known the remarkable record that Robert Adams left of his work when he died in 1984.

While the Tate Gallery is fortunate to own a number of Adams's sculptures and prints, the generosity and collaboration of his widow Mrs Patricia Adams, and of their daughter Mrs Mary Adams Weatherhead, made it possible for the Tate Gallery Archive to acquire almost all of his surviving sketchbooks and loose drawings, small maquettes, some collages, photographs, and his notes and correspondence. Together they form a marvellous sequence in which Adams's development as an artist can be followed from his beginnings in the mid-1940s to a few years before his death. In particular, the twenty sketchbooks demonstrate a remarkable and constant flow of creative energy as the ideas develop in rapid succession. Adams considered most of them as 'suggestions for sculpture', as a means of germinating and developing ideas which stopped short of the final goal: he believed that solutions had to be achieved in the material of the sculpture itself.

We were very pleased to have the participation of Alastair Grieve who has a unique depth of knowledge of Robert Adams's work. Not only has he completed this book and the detailed listing of the Adams archive, but he has also just completed a catalogue raisonné of Robert Adams's sculpture published by Lund Humphries. In his

narrative for the Tate publication he relates many of the themes and drawings to the sculptures, which offers the reader a fascinating insight into Adams's creative thinking.

Nicholas Serota
Director

Author's Note

I first met Robert Adams in the spring of 1978. At that time I was studying the group of artists who had joined with Victor Pasmore in the 1950s to produce a rigorously constructed, abstract, art. So I was primarily interested in Adams's work of 1950–6 when he had been part of this avant-garde group which included, as well as Pasmore, Kenneth Martin, Mary Martin, Adrian Heath and Anthony Hill. Although I saw Adams's latest work with him in his studio and in his solo exhibitions in 1978 and 1979, I was specifically interested in his move into abstract forms in his work of the early 1950s. On the occasions when I visited him in his studio at Great Maplestead in Essex, he was extraordinarily tolerant of my blinkered, historical concerns and he searched out works and photographs from that early period. Then I also met his wife Pat and his daughter Mary whose help was later to be invaluable.

It was Pat Adams who, after Robert died in 1984, encouraged me to write a book covering his entire career, from his first figurative carvings made at Northampton in the early 1940s to his last abstract works in bronze. At Great Maplestead I studied the sketchbooks and sculptures remaining in the Estate. At Gimpel Fils Gallery, where he had exhibited regularly since 1947 and where I was assisted by the Gimpel family and by Derek Keen, I recorded the stock of his sculpture of all periods. In London too, I was sustained by the enthusiasm of Joyce and Michael Morris who own the finest private collection of Adams's sculptures.

In April 1987 grants from the Henry Moore Foundation and the British Academy enabled me to visit the United States. There I looked at Adams's large welded steel sculptures of the late 1950s and 1960s, collected by major American patrons such as Seymour Knox, James and Lillian Clark, and Joseph Hirshhorn. Back in England there were enjoyable discussions with Adams's friends in Cornwall, Denis Mitchell, Terry Frost and Wilhelmina Barns-Graham. Tours to see the architectural relief at

Gelsenkirchen in Germany and to the archive of the Venice Biennale enabled me to place Adams in the wider context of contemporary European abstract sculpture.

The book on his sculpture was largely complete by the summer of 1988. Further work had to be done to provide a catalogue raisonné of nearly seven hundred sculptures, as requested by the Henry Moore Foundation, joint publisher with Lund Humphries. Later in 1988 came the suggestion from Sarah Fox-Pitt of the Tate Gallery that I should catalogue and publish a summary in book form of the important Adams archive which the Tate Gallery Archive had acquired through the generosity of Pat Adams and Mary Adams Weatherhead. This consists of a remarkable group of sketchbooks and studies, maquettes and records of work, correspondence and printed material.

It is my firm belief that the work of Robert Adams deserves an updated and wider recognition. Adams's sculpture was always admired by artists and architects of his generation, as well as collectors, patrons, exhibiting officials and galleries worldwide and I hope that these two books will stimulate the interest of a new generation of admirers in the work of one of the finest sculptor's of his time.

Acknowledgments

My research on Robert Adams began many years ago but more recently I have been preparing a book on his sculpture which is due to be published simultaneously. For this study I have drawn on some of the material of those researches, but for reasons of space I cannot duplicate the full list of acknowledgments here. However, I would like to mention all those people and institutions whose help has been invaluable to the work associated with this book: Mary Adams Weatherhead; Iain Bain of Tate Gallery Publications; Michael Brandon-Jones of the University of East Anglia; The British Academy; Erlend Brown of the Pier Arts Centre, Orkney; Frances Carey of the British Museum; Rita Charles of the British Council; Lillian B. Clark; Uta and Christopher Frith; Peter, Catherine and Kay Gimpel; Felicity Hebditch of St Albans Museums; Nehama Hillman; David Jones of the Bridewell Museum, Norwich; Derek Keen; the Henry Moore Foundation; Dr Michael Morris; Stephen Rabson of P&O; Timothy Rendle; Herbert and Tess Robinson; Virginia Smithson of the British Museum; Dr Eileen Scarff of St George's Chapel, Windsor; Ronald Weeks; Colin Westwood; James Williams. Sarah Fox-Pitt, Jennifer Booth, Valerie Harper and the staff at the Tate Gallery Archive deserve my special thanks for their patient cooperation and assistance. Sabbatical leave from the University of East Anglia gave me the time to write.

Alastair Grieve

Robert Adams

It is commonplace but true that wave after wave of impressive, avant-garde sculptors have emerged in Britain over the last century. Robert Adams, born in 1917, belonged to the generation who came to prominence after the Second World War and won international acclaim at the Venice Biennale of 1952. This generation includes Kenneth Armitage, Reg Butler, Lynn Chadwick, Geoffrey Clarke, Bernard Meadows, Eduardo Paolozzi and William Turnbull. Adams represented Britain again ten years later at the Biennale and he continued to exhibit in major exhibitions in this country and abroad until shortly before his death in 1984. Despite this, he has never been very well known here. His art is abstract and unassertive. It depends largely, though not entirely, on formal values perceived by the eye. Such qualities are not popular and if he had not had the regular support of his dealer Gimpel Fils, the Arts Council and the British Council, and a few well-informed patrons from the United States, he would not have been able to survive in his chosen career of sculptor.

Adams grew up in the village of Hardingstone, near Northampton. He left school at the age of fourteen and then did various manual jobs, making agricultural machinery for example, which accustomed him to the use of wood and metal-working tools. He attended evening classes at the Northampton School of Art and became an accomplished draughtsman in the life class and a painter of portraits, landscapes and still life in oils. But there was no sculpture class, so in sculpture, which was what he wanted to follow, he was largely self-taught. In 1946–7 he gave up his job and, living off his savings, devoted himself full time to carving.

His first interesting works are a group of abstract carvings in wood with asymmetrically balanced, spiralling, bud forms. Their size, and the tightness of the spiral, are determined by the grain of the wood and they are produced as a closely related group. In these ways, they forecast his later sculptures, whose forms are always at

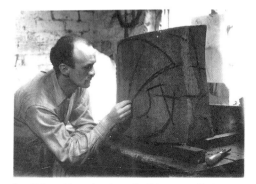

fig.1 Robert Adams drawing a 'bud' form on a block

one with their material, whether it be wood, stone, steel, marble or bronze and which always have implied movement and are produced in series. Adams himself remarked on these characteristics in his earliest known statement about his sculpture, referring to the abstract 'bud' carvings:

> Movement plays a great part in my sculpture, not actual, but imagined. The same twisting movement that a spiral has.
>
> I like to do things in series, carrying through one set of ideas as far as I can.
>
> When the idea of the work to be carved is formed, exactly the right material must be found. The size of the piece, colour and texture of the material must all be in accord.[1]

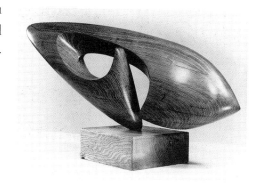
fig.2 'Carving in Oak' 1947 Oak 25.4 × 48.9 (10 × 19¼) *Matthew Frost* (G.27)

Several of these 'bud' carvings were shown at his first one-man exhibition in London in the winter of 1947–8. This was at Gimpel Fils Gallery, one of the very few commercial galleries willing to show contemporary art at this time, which continued to give him regular exhibitions for the rest of his life. During the next few years, Adams rapidly moved from being an obscure provincial artist to one of the most promising sculptors in the British avant-garde. In 1948, he visited Paris, following an introduction to the French sculptor Maxime Adam-Tessier, who was taught by Henri Laurens. This introduction led to a long-lasting friendship and Adam-Tessier enabled Adams to visit the studios of several prominent Paris-based sculptors, including Constantin Brancusi.[2] In the following year he exhibited in Paris, and again at Gimpel Fils, and started to teach at the Central School of Art in London. In 1950 he spent three months in the United States, where he met artists of the New York school, including Alexander Calder, and studied the teaching methods at the Chicago Bauhaus. The Arts Council commissioned him to produce a large sculpture for the Festival of Britain in 1951, and in 1952 his work was exhibited at the Venice Biennale under the auspices of the British Council.

His sculpture during this period, from 1948 to 1951, is of abstracted figures of various types, again arranged in series. In one group, heads, torsos and limbs are reduced to conical forms. In another, limbs are drawn out to spindles, and shoulders

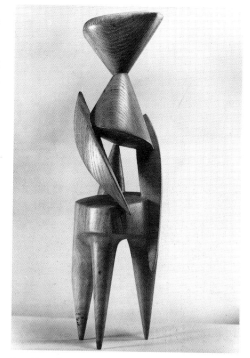
fig.3 'Figure' 1948 Elm 34.3 (13½) *Private Collection* (G.70)

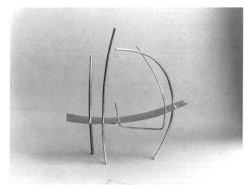

fig.4 'Pierced Sheet' 1952 Brass 29.2 x 27.9 (11½ x 11)
Morris, London (G.139)

and pelvises resemble connecting, tilting, bridges. Solid and void are balanced. Other sculptures, more open still, are not carved from blocks but constructed from rods of wood or brass formed into geometric curves, triangles and straight lines. The constructed, architectonic quality of his work distinguishes it from the spiky, waspish character of the sculpture of his contemporaries showing at Venice.

By 1952, Adams was making abstract sculpture again – a series of cubic or cylindrical blocks raised on short necks, full of compressed energy, carved from wood and stone, and another series of open, brass constructions with rods, like plant stems, bending according to their thickness. His move into abstract art in the early 1950s was gradual, and the distinction between figurative and non-figurative in his work is not important, but the move was encouraged by a friendship formed with the painter Victor Pasmore, a colleague at the Central School. Pasmore had converted dramatically to abstract art in 1948 and was gathering around himself a group of artists who shared his belief that abstract art, of a rigorously constructed, geometric kind, was the only way forward. Because of the strong hostility to such art in England at this time, Pasmore and his friends organised their own exhibitions and publications, the best known being the book, edited by Lawrence Alloway, and accompanying exhibition titled *Nine Abstract Artists* of 1954–5. Adams contributed not only sculpture but also collages and prints to their exhibitions. He went on, like them, to collaborate with architects in the important environmental exhibition *This is Tomorrow* in 1956 at the Institute of Contemporary Arts, London.

Because of the abstract, architectonic character of his sculptures, they were admired by many young architects, and during his life Adams probably received more architectural commissions than any other British sculptor. In 1957 he competed successfully with an international team of other artists, including Yves Klein, Jean Tinguely and Norbert Kricke, to provide art for the city theatre at Gelsenkirchen in the Ruhr. Adams always regarded the enormous, reinforced concrete relief he made at Gelsenkirchen as his most important architectural work, largely because collaboration with the architect, Werner Ruhnau, had begun in the early stages of the building, rather than later as was often the case. At the same time, he designed a large cement relief for the London County Council's Eltham Green School and in 1958

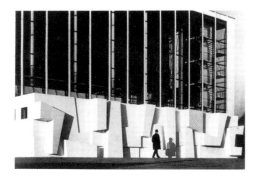

fig.5 'Wall Relief' 1957 Reinforced concrete 274 × 2194
(108 × 864) *Gelsenkirchen City Theatre, Germany* (G.220)

another relief for public gardens in Hull. Major commissions continued to come to him in the 1960s and 1970s, despite radical changes in his style and techniques.

One such radical change had occurred in his free-standing sculpture shortly before he received the Gelsenkirchen commission in 1957. At Gimpel Fils in February 1956 he showed his last woodcarvings. This series, aptly titled 'Counterbalance', made of polished mahogany, have long, conical limbs extending far out from single, tapering supports. With them, Adams must have felt that he had reached the limits of carving and he turned to welding in iron rod and steel sheet. The suggestion of movement had always been one of his main aims and the change in materials gave him new ways of doing this. He stated later:

I am concerned with energy, a physical property inherent in metal.[3]

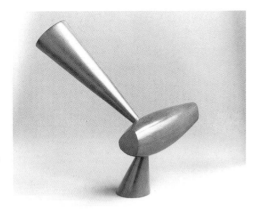

fig.6 'Counterbalance No.2' 1955 Mahogany 43.2 × 43.2 (17 × 17) *Morris, London* (G.191)

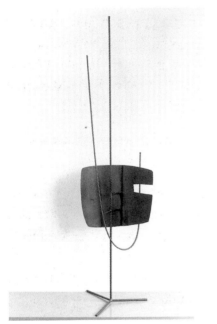

fig.7 'Reacting Curved Form No.1' 1957 Bronzed steel and iron 142 (56) *Morris, London* (G.212)

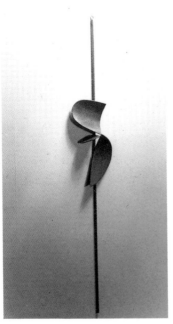

fig.8 'Curved Forms (Maquette)' 1960 Bronzed steel 55.9 (22) *Private Collection* (G.329)

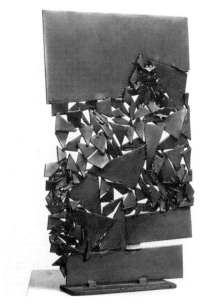

fig.9 'Open Screen Form', 1962 Bronzed steel 48.9 × 39.8 (19¼ × 15½) *Private Collection* (G.386)

Many of the welded sculptures of 1956–8 have a stable, vertical rod, acting as a spine, around which curl planes of steel, cut into contrasting horizontal/vertical pointing spikes, supported by subsidiary rods. Movement in three dimensions is important, around the vertical rod, but so is the dark silhouette of the metal forms against the light. Contrast between dark and light coupled with movement remained a major concern for the next decade and this often meant placing the sculpture where its silhouette was most striking, against the sky or a light wall, confronting the viewer. At his 1960 Gimpel Fils exhibition, Adams exhibited a series of wall-hung works, each made from a single, vertical rod supporting, and acting as a foil to, a cluster of three planes. The planes point in different directions, their movements cancelling each other out in a balanced, visual equation. He also started a series of welded screens which were to develop through many variations until 1967.

The overall form of each screen is an upright, rectangular plane. They are built up from segments of sheet steel which are also often rectangular, but sometimes triangular. Slightly irregular silhouettes and shallow, rippling changes in surface depth are created by the numerous welded segments. Slits and chinks of light penetrate them. Sometimes Adams accentuated the dark/light contrast with bold vertical or horizontal cuts or carefully placed, though apparently naturally formed, lines of drilled holes. He remarked, when discussing 'Screen with Slats', 1965–6, shown at Battersea Park in 1966:

> I am ... interested in contrasts between linear forces and masses, between solid and open areas ... the aim is stability and movement in one form.[4]

The contrast between light and dark is further accentuated by their tone, because, in order to protect them from rust, Adams had them sprayed with a bronze skin which he patinated so that it is almost black. He wanted, he said, 'to keep steel looking like steel.'[5]

While the screens are made to be viewed from front or back, other sculptures of welded sheet steel made in the 1960s encourage all-round viewing. This is true of a series titled 'Balanced Forms', which have large, flat, rectangular planes, proportionally balanced and angled against each other, raised upon square section bars.

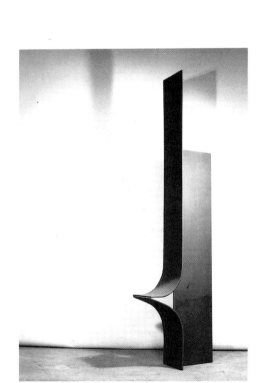

fig.10 'Curving Flange 3', 1968 Bronzed steel
157.9 × 20.3 × 45.7 (62 × 8 × 18) *Fayez Sarofim Collection, Houston, Texas* (G.544)

The largest of these, eight feet five inches high, was exhibited at Battersea Park in 1963 and its dark, elegantly spreading forms must have contrasted markedly with Caro's bright yellow 'Mid-Day' and one of David Smith's flashing 'Cubi', in brushed stainless-steel, which are on a similar scale and were shown in the same exhibition. Adams's last sculptures in sprayed steel, shown at Gimpel Fils in September 1968, encourage viewing both from the front, where they are emphatically asymmetric, and from the side, where they are symmetric. These are satisfyingly simple, monumental works made of two or three flat, rectangular, steel slabs juxtaposed in 'T' formation and curved through ninety degrees at a focal point.

The major patrons for Adams's welded steel sculptures were well-known collectors from the United States: James and Lillian Clark, Joseph Hirshhorn, Seymour Knox, Raymond and Patsy Nasher and Fayez Sarofim. But despite their backing and despite the confidence shown in the large works in his 1968 exhibition, Adams returned in this year to carving sculptures on a much smaller scale. He began with a series of book-shaped, chromed steel reliefs and free-standing blocks with scalloped edges. In 1970, he carved a series in Sicilian marble and he also began once more to make bronzes from carved wooden patterns. His change coincided with a renewed interest in landscape and in 1971 he moved his home and studio from London, where he had lived since 1951, to a rural cottage in Essex.

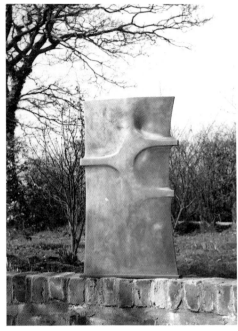

fig.11 'Slim Bronze No.4', 1971–2 Bronze 73.7 × 43.2 (29 × 17) Ed. of 6 (G.604)

There are suggestions of landscape and seascape forms in many of the seventy-five or so bronzes he made during his last decade of activity. The majority of the bronzes are small, intimate, densely solid works cast in sand moulds and individually ground, polished and patinated. From the slightly hollowed or swelling faces of rectangular slabs or cylindrical blocks emerge flat-topped ridges or ovoid sockets polished to a warm gold in distinction to the gritty brown exteriors. In one series, folds and raised crescents suggest gathering waves. In another series, a cross-shaped relief perhaps derives from the abstracted pattern of a branching tree which Adams sketched, and may also be intended as a Christian cross, for he had become a Roman Catholic at his marriage in 1951 and remained a believer. The last bronzes of 1980 are a series of flat ovoids with circular depressions in their faces suggesting the beds of seeds or a womb enclosed within a protecting body.

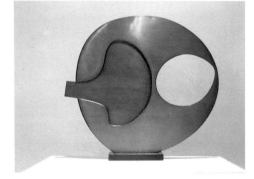

fig.12 'Ovoid Variation No.6 (Peacock)', 1980 Bronze 45.7 × 52 (18 × 20½) Ed. of 6 (G.674)

Sketchbooks and studies

There are studies for many of the sculptures mentioned above in the sketchbooks in the Tate Gallery Archive. They are working sketchbooks and the studies in them were not intended for exhibition. When Adams did exhibit drawings, he presented them as works of art in their own right, parallel to his sculptures, prints and collages.[6] The earliest sketchbooks, of the mid-1940s, contain many compositional studies for naturalist paintings and records of his surroundings, the places he worked, and landscape subjects which caught his eye. There are studies drawn as exercises in, for example, capturing the movement of animals, or light and dark on a still life. But from 1948, the studies are focused on projects for sculpture, though these are still interrupted occasionally by fine drawings of his sources of inspiration such as primitive tools, leaves or waves.

As working sketchbooks, they show us how Adams considered ideas for sculptures. They emphasise that he worked in series. He would not draw over an individual study to refine it, but instead made another drawing alongside showing variations, and then another and another, until the page was covered in rows of possible solutions. He drew fluently, making few alterations and, though he also worked quickly as a sculptor, he was never able to realise all the ideas present in the studies. The few drawings for sculptures in the earliest sketchbooks show them carefully shaded, from several viewpoints but, again from 1948, shaded three-dimensional views become rarer and most studies are rapid outlines. Silhouette, as we have seen, is important for his sculpture and his method of recording his ideas accords with this. His drawing medium varies according to the material of the intended sculpture. For example, he used black ink in studies for the linear, steel sculptures of *c.*1957 and delicate pencil for the marbles and bronzes of 1970–2. Most of the studies for sculptures without specified sites are small, without indications of scale, drawn many to a page, but drawings for commissioned architectural sculptures are larger, squared-up and measured.

The sequence of some drawings gives us an insight into Adams's abstracting process. For example, the many drawings of religious subjects, particularly those of

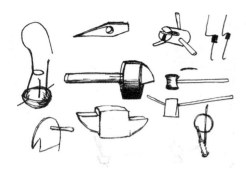

fig.13 Studies of tools and other artefacts
TGA 8421.1.18, f.10

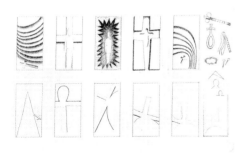

fig.14 Studies for abstract reliefs symbolising the Stations of the Cross and the instruments of the Passion for Clifton Cathedral, Bristol TGA 8421.1.47, f.9

the Stations of the Cross of *c.*1969–70, show the transition from quite realistic though simplified scenes, to abstract symbols, the specific message of which is difficult to read. And the drawings of waves, though arranged in decorative linear patterns within rectangular borders, are at once recognisable as waves, whereas the sculpted wave forms are primarily abstract contrasts of movement, inspired by observation of waves rather than a desire to represent them. We are fortunate that the sketchbooks have been preserved and that, through them, we have such insights into the ideas behind his sculptures.

In the following pages the sketchbooks and drawings are discussed in chronological order. They begin with naturalistic studies made while Adams was a part-time art student during the Second World War and from where they develop fast, through the abstracted figure compositions of 1948–51, the abstract carvings and constructions of the first half of the 1950s, the change to linear welded metal sculptures and large works in sheet steel which occupied him to 1968, the return to subtractive techniques and the last, enigmatic bronzes of *c.*1980.

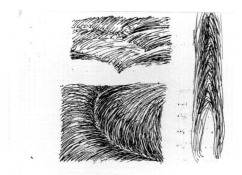

fig.15 Drawing of waves TGA 8421.1.53, f.4

Notes

1 From a manuscript, probably written by Adams in the summer of 1947, in a private collection.
2 Maxime Adam-Tessier, in conversation with the author, March 1989.
3 N. Hillman, *Robert Adams, A Critical Study and Complete Catalogue*, New York University Institute of Fine Arts 1969, p.13. Unpublished dissertation, Tate Gallery Archive, TGA 8318.32.
4 C.S. Spencer, 'Profile, Robert Adams', *Arts Review*, vol.18, no.16, August 1966, p.385.
5 Hillman 1969, p.11.
6 In a catalogue note to his exhibition at Gimpel Fils in April 1949, Adams wrote of twenty-one drawings in the show: 'These drawings, which have pictorial qualities in themselves, are suggestions for sculpture. A means of germinating an idea and bringing it forward, but always stopping short of the final goal. For, the artist believes that the final problems must be solved in the material itself.'

Catalogue

Entries are in a chronological sequence, divided into nine categories: sketchbooks and studies; records of work; collages; maquettes and three-dimensional objects; correspondence; personal papers; photographs; presscuttings; and the self-portrait. Each item is identified by its Tate Gallery Archive accession number. Some items, such as the correspondence, have been grouped together for the purposes of this publication; a more detailed catalogue treating every item individually can be consulted in the Tate Gallery Archive.

Other sketchbooks and studies by Adams are also in the collections of the British Museum, Gimpel Fils Gallery, and Mary Adams Weatherhead.

The titles given to the sketchbooks are not intended to be fully descriptive of their contents; they are simply catchwords for easier reference.

For reasons of legibility, illustrations from the sketchbooks and studies concentrate on the image area; where the image occupies only part of a folio, the blank paper surrounding it is not shown.

Measurements are given in centimetres, followed by inches in brackets, height before width before depth. For finished sculptures, the dimensions are given as fully as possible from the information available; in some circumstances this may be height, or height and width, only.

'G' numbers refer to the catalogue raisonné of Robert Adams's sculptures, written by Alastair Grieve and co-published by the Henry Moore Foundation and Lund Humphries, 1992.

Sketchbooks and Studies

Northampton sketchbook 1, *c*.1944

Pencil, red and blue crayon, and ink on unbound off-white paper with rounded corners and rusty staple marks:
62 sheets
25.4 × 18.4 (10 × 7¼)
TGA 8421.1.1

This sketchbook is one of the earliest to survive and probably dates from *c*.1944. Adams was a conscientious objector during the Second World War and worked in a reserved occupation making agricultural machinery. Many of the studies in this sketchbook were drawn at his workplace. He was employed by Cooch & Son of Northampton who specialised in elevators and potato sorters. The wooden frames of the elevators seem to have particularly attracted Adams. He drew them stacked together, leaning against each other or nesting upright. He mastered the problem of perspective which they posed and he gave their odd, tapering forms, with broad bases and inclined 'heads' an almost figurative suggestion. He carried some of the studies of elevator frames further in watercolours which survive (private collection). They are dated 1944 and were exhibited then, with his early sculptures, in exhibitions arranged for artists working for Civil Defence, at the Cooling Galleries in Bond Street.

Other studies in this sketchbook are of men working belt-driven machines such as lathes, of the machines themselves, and of sawn wood seasoning in

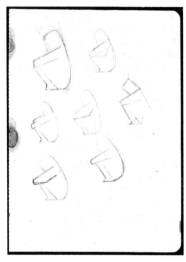

Profile views of a crouching figure, probably for a sculpture
TGA 8421.1.1, f.1

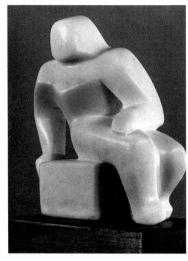

'Seated Figure', 1947 Marble approx. 8.9 (3) (G.43)

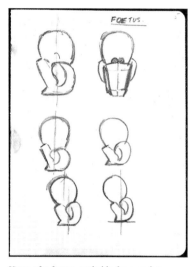

Views of a foetus, probably for a sculpture
TGA 8421.1.1, f.5

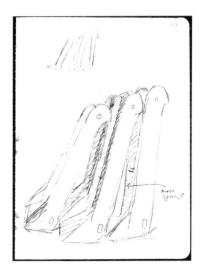

Studies of stacked frames of agricultural elevators
TGA 8421.1.1, f.13

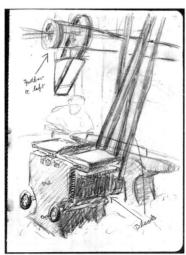

Study of man on belt-driven wood-working machine
TGA 8421.1.1, f.17

stacks. All the studies have a matter-of-fact quality. They are records of what caught his eye in his everyday life. They also remind us that Adams, who had left school at the age of fourteen, was a practical man who had a familiarity with machine tools and with working in wood before he began to devote all his time to his art. Up to *c*.1955 most of his sculptures are carved or constructed from wood, and afterwards, when he made his sculpture from steel or bronze, he continued to use machine tools readily and with great skill.

There are other studies in this sketchbook, of landscapes, farm buildings and animals, which were made in the countryside around the village of Hardingstone, near Northampton, where Adams lived until 1951. The landscapes have asymmetrically balanced compositions, often contained in rectangular borders drawn within the pages, of receding lanes and hedges, grouped buildings and massed trees. Throughout his life, Adams looked to trees as models of harmo-

nious growth. There are no figures in the landscape studies but other studies in this sketchbook show figures in domestic settings caught in characteristic actions or sitting in relaxed poses. There are also several outline studies of a cat asleep and of chickens, ducks and a calf in movement.

While the majority of the more finished studies are for paintings, several having colour notations, there are two pages which are exceptional as they show studies for sculpture. One of these pages has studies of a foetus, the other of a crouching figure. These studies are drawn several times in outline. Forms are abstracted, simplified to basic shapes, and contain a sense of compressed force within their bounding lines. They are symmetrical from front and back. They are more advanced, more avant-garde, than the other drawings in the sketchbook and relate in style and subject to the sculptures of Jacob Epstein and Henri Gaudier-Brzeska of *c*.1913. It is not known if Adams actually made sculptures from these studies.

Study of stacked, sawn, trunks
TGA 8421.1.1, f.21

Studies of sleeping cat
TGA 8421.1.1, f.50

Two Northampton sketches

'Standing Workman', *c.*1940–6

Pencil on off-white paper: single sheet
25.4 × 18.4 (10 × 7¼)
Mounted with oval stamp on verso:
COOCH & SON/MAKERS/
NORTHAMPTON/THE R.A.S.E./
FIRST PRIZE POTATO SORTER
TGA 8421.1.2

This rapidly drawn contour drawing
has a stamp on the verso which refers
to the firm of agricultural machinery
makers with whom Adams worked
during the Second World War.

'Self-Portrait', *c.*1940–6

Pencil and charcoal on thin off-white
paper with rounded corners
25.4 × 18.4 (10 × 7½)
TGA 8421.1.3

This is possibly from the *Northampton*
sketchbook 1 or 2 (TGA 8421.1.1,
above or 8421.1.4, below).

Northampton sketchbook 2, *c.*1944–7

Pencil and sanguine on off-white,
unbound sheets with rounded corners:
74 sheets
25.4 × 18.5 (10 × 7¼)
TGA 8421.1.4

This sketchbook may have been
started at about the same time as
the *Northampton* sketchbook 1 (TGA
8421.1.1, above), i.e. *c.*1944, but was
probably continued to a later date,
perhaps to *c.*1947. As in the *Northamp-
ton* sketchbook 1, there are many
compositional studies of landscapes
within rectangular drawn borders.
They are firmly structured with bold
light and dark masses formed by banks
of trees and architectural elements such
as houses, walls or strawricks. Adams
was fond of views leading into the
picture space, down a lane, along a
hedge-side or curving village street. As
in the first sketchbook, these landscape
studies contain no figures but there are
other folios with squared-up, finished
studies for portraits of friends, or
members of his family, in relaxed poses.
There are also records of his everyday
environment: drying clothes, chimney-
pots, a lorry parked in the street.
Again, there are rapid outlines of
animals which here include a series
drawn in a zoo of exotic beasts and
birds recorded in motion.

This sketchbook also contains a few
studies for sculptures. Two folios have
studies of a nude female dancer, a
sculpture of which, carved in elm
(45.1 cm high), is known from a
photograph. Unlike the studies for
sculpture in the previous sketchbook,
these attempt to capture the figure in
motion and the dancer is shown
turning, rather awkwardly, with her
body twisted in a spiral. This dancer is
the first of several drawn and sculpted

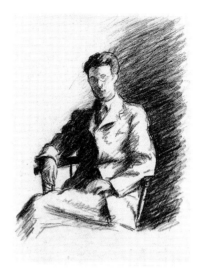

Study of young man [Dr P. Kirwan] for an oil
portrait
TGA 8421.1.4, f.8

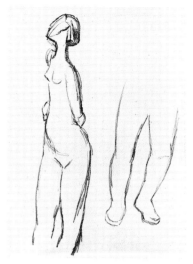

Study of nude female dancer and study of
her legs, for a sculpture
TGA 8421.1.4, f.28

'Portrait of Dr P. Kirwan', exhibited in
Northampton Public Library, April 1946
Untraced

Studies of the wood carving of an abstract
figure (Pier Arts Centre, Orkney)
TGA 8421.1.4, f.52

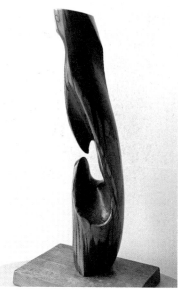

'Standing Figure', c.1947 ?Yew 27.9 (11)
Pier Arts Centre, Orkney (G.17)

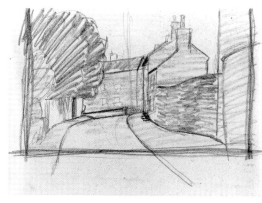

Study of a village street
TGA 8421.1.4, f.64

by Adams and the suggestion of controlled movement, of asymmetric balance poised for a moment, remained important in all periods of his work.

There are other studies for more abstract sculptures. Some are for rounded, organic forms, with hollowed insides and pierced holes, which show the influence of Moore and Hepworth. Axial lines drawn through the mass, as well as written notes about the centre of gravity, testify to Adams's concern to balance the swelling forms on small, rounded, bases. No sculptures have been traced which follow these studies but a sculpture does survive for which there are studies on adjacent pages. This sculpture is a very abstract figure with a twisting, cylindrical body narrowing to a faceted head (Pier Arts Centre, Orkney). At the front, the body is hollowed out with a large, oval cavity which it enfolds and protects.

Beside one of the studies for it is a smaller study for a related though more abstract form resembling a curled bud. At his first one-man exhibition at Gimpel Fils Gallery in the winter of 1947–8, Adams showed a series of abstract carvings with similar bud-like forms.

Northampton sketchbook 3, c.1947

Black crayon on rough, light brown flecked paper: 13 sheets (several torn out)
Buff, hard cover, no title
30.4 × 24.7 (12 × 9¾)
TGA 8421.1.5

This sketchbook contains only one drawing, a study for a formal portrait of an old man with a moustache, smoking a pipe and wearing a top hat. From a newspaper clipping in the Archive collection and from information from the Northamptonshire County Archivist, Miss R. Watson, and the late Mrs Pat Adams, the sitter can be identified as the Northampton Coroner Albert Joseph Darnell, who died in 1955.

There are more studies of the same sitter in the *Northampton/'Paris'* sketchbook (TGA 8421.1.6, below), and amongst some loose studies in a private collection. They are preparations for a commissioned oil portrait.

Northampton/'Paris' sketchbook, c.1947–9

Pencil on thin white bank paper with
perforations on left side: 66 sheets
(incomplete)
Grey-green cover printed with 'The
RAPID Sketch Book Series 46',
'WINDSOR & NEWTON LTD'
25.4 × 20.4 (10 × 8)
TGA 8421.1.6

This is a full and very interesting
sketchbook which spans the years
1947–9. At the start of this period
Adams was still an unknown provincial
artist, while by 1949 he was establish-
ing a reputation as one of the most
promising young sculptors of the
avant-garde with one-man exhibitions
at Gimpel Fils Gallery in London and
the prestigious Galerie Jeanne Bucher
in Paris. The sketchbook starts with
careful studies for a commissioned
portrait of Albert J. Darnell (see TGA
8421.1.5, above) and studies of mem-
bers of an orchestra which show his
ability to capture individual gestures
and to suggest particular movements
of the body. There are fewer landscape
studies than in the earlier sketchbooks,
but there are some studies at the start
of bare trees and of trees in leaf and a
fine series of carefully observed draw-
ings of massive felled trunks and
stumps. Adams was clearly fascinated
by the forms produced by the tree's
growth and dismemberment, the
hollows and the twists in the trunk,
the surprising angles and flat ends of
radiating, sawn off, limbs. His observa-
tion of the natural form of the wood
distinguishes his tree studies from those
of Graham Sutherland, with which
they inevitably invite comparison, for
Adams's trees are not anthropomorphic
and he was never a Surrealist.

 Adams's respect for the natural form
of wood is also very evident in his

Studies for an abstract sculpture related
to the 'Bud' series of 1947
TGA 8421.1.6, f.18

Study of a tree-stump and felled trunk
TGA 8421.1.6, f.21

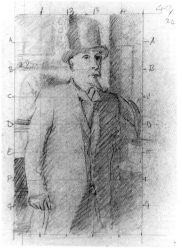

Squared-up study of Albert Joseph Darnell
annotated for transfer to canvas
TGA 8421.1.6, f.3

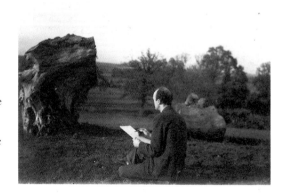

Robert Adams sketching in the countryside
near Hardingstone, c.1947

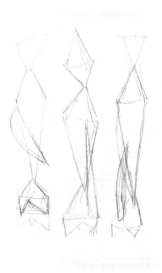

Studies for sculpture of abstract standing figures of carved wood
TGA 8421.1.6, f.47

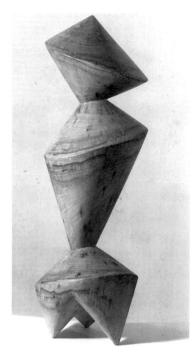

'Dancer', 1950 Elm 82.5 (32½) *Untraced* (G.109)

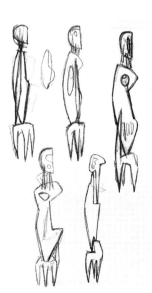

Studies for abstract standing figures
TGA 8421.1.6, f.52

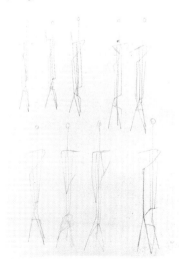

Linear rod figures
TGA 8421.1.6, f.61

studies for abstract carvings, probably dating to 1947, which occur in this sketchbook close to the studies of felled trees. There are studies of a ring-shaped sculpture of wood, perhaps carved from a cross-section of trunk with the core removed, with swelling points which recall those in Jean Arp's sculptures. And there are other studies for a series of abstract, spiral, 'bud' carvings which were made from various woods also in 1947. The size of these spiral 'buds' and the degree to which they unfold is determined, Adams explained, by the grain and density of the wood used.

After this, over halfway through the sketchbook, there is a marked change. Studies from landscape subjects cease altogether and there is a concentration on a variety of very abstract standing figures intended for sculptures. These figures show an excited awareness of Parisian avant-garde sculptures by Picasso, González, Brancusi, Laurens and others as well as of works by Moore and Hepworth.

Adams probably drew them at about the time of his visits to Paris in May to June and September to October 1948 and may have continued into the following year. Many of the later studies are for series of sculptures shown at his second exhibition at Gimpel Fils Gallery in April 1949. The studies themselves are arranged in series, often in rows across the page, and show the artist's fecund experimentation with a variety of types of standing figure. A few (f.30) can be related to the Tate Gallery's 'Figure', 1949 (T 0 3866), carved from yew, and two untraced figures of Bath stone which have drawn-out, spindle-like limbs with pelvises, torsos and shoulders formed from slanting, horizontal discs and bridges with voids between. Other drawings are for a series of more contained carved wood figures with heads, torsos and limbs reduced to

cones. Another large group of studies are for linear figures to be constructed, rather than carved, from rods of wood or metal. Movement is suggested by diagonal or curved limbs set asymmetrically against a dominant vertical spine. The figures stand on three points. These linear figures invite comparison with Reg Butler's contemporary sculptures of welded iron, first exhibited in July 1949, but Adams uses more regular geometric forms than Butler. Adams constructed some of his figures from brass wire which he brazed – the 'Presentation' studies (TGA 8421.1.9, below) show a later scheme to greatly enlarge these constructed figures. He learnt this technique at the Central School where he started to teach early in 1949. The same type of linear figures occur in his contemporary prints which were also probably made with equipment and the advice of craftsmen at the Central School. (For information on Adams's prints of this period see F. Carey and A. Griffiths, *Avant-Garde British Printmaking 1914–1960*, British Museum 1990, pp.198–201.)

'Paris' sketchbook 1, *c*.1948–50

Pencil, black and blue ink, black and green wash, and blue crayon on thin white paper: 37 sheets
30.3 × 44.4 (12 × 17½)
TGA 8421.1.7

This group of studies on loose sheets of paper must have been drawn at the same time as the last section of the *Northampton/'Paris'* sketchbook (TGA 8421.1.6, above). They also show an excited awareness of avant-garde sculpture in Paris and again some were probably drawn at about the time of Adams's visits there in 1948 (see TGA 8421.1.6, above). Many studies are for sculptures shown at his one-man exhibition at Gimpel Fils in April of the following year. Almost all are of abstracted figures drawn rapidly in outline in pen and pencil, with two, three, or more to each page.

The figures are of several types. One type relates to sculptures of bathers, made of reinforced plaster and wood. These figures are shown in motion, holding a ball between their hands, balancing on three tapering legs, rearing beak-like heads on long necks. Their forms are rapidly created with a continuous wiry line which flows and doubles back on itself. Another group of studies is similar to small sculptures of female nudes made from cement on metal armatures. Some of these figures are quite naturalistic, with large hips and thighs, animated arms, and small heads. Others are a Picasso-inspired fusion of woman and flower. The studies show women with petal heads, and arms suggested by long, bent leaves. One of these pages is inscribed 'universality'. The studies for carved wood figures with heads, torsos and legs formed from cones balanced one

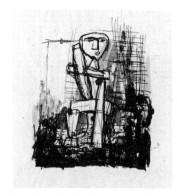
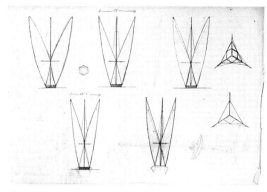

Drawings of abstract figures, resembling sculptures of Bath stone of 1949 (1 drawing reproduced)
TGA 8421.1.7, f.1

Elevations and plan views, for a 'Skylon' type construction possibly planned for the Festival of Britain in 1951 or for a new town in Kuwait designed by Frankland Dark 1953–4
TGA 8421.1.7, f.3

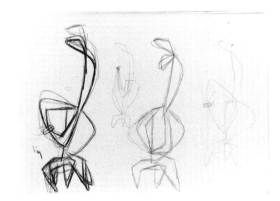

Studies for sculptures of bathers with joined hands
TGA 8421.1.7, f.15

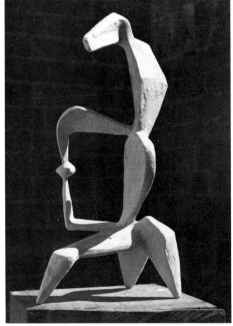

'Bather with Ball', 1948 Reinforced plaster
54.6 (21½) *Untraced* (G.56)

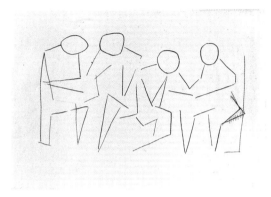

Linear study of four abstract figures
TGA 8421.1.7, f.29

Studies of abstract figures resembling
sculptures of 1949
TGA 8421.1.7, f.32

Outline studies for abstract standing figures
(the left-hand one resembles a carving of
1949) and for animals
TGA 8421.1.7, f.36

above the other (already seen in the *Northampton/'Paris'* sketchbook, TGA 8421.1.6, above, and inspired perhaps by Brancusi's 'Columns') are continued in a further sequence here. One of these sheets of studies for sculptures formed from cones is energetically inscribed 'PARIS'.

Adams abstracts the human body, representing it by simple, basic forms in almost all these studies, but he carries the process furthest in a series of outline drawings of a row of four or five seated figures. Their heads are represented by circles and limbs by interconnected triangles. Here Adams seems to be testing the limits of abstraction, yet he succeeds in retaining a sense of animated discussion between the seated figures. These were probably not intended as ideas for sculpture.

Very different are two studies on one page which match closely two carvings of abstracted figures in Bath stone (exhibited Gimpel Fils 1949, untraced). Here the figures are brought forward by surrounding washes of black ink touched with red. There is one other folio with drawings in a similar style of a standing nude boy and girl. These resemble a sculpture in reinforced concrete which Adams made in *c.*1950 for Kings Heath Lower School, Northampton. Perhaps because of the nature of this commission, the only one Adams received from his native city, and of the site, an infant school in the middle of a new housing estate, it is more naturalistic than the majority of his sculptures of this period. In the figures in Bath stone and in the carvings in wood for which there are studies here, made for display in avant-garde exhibitions in London, parts of the body are radically simplified, taken apart and reassembled to satisfy a search for an animated, yet harmonious, balance.

'Paris' sketchbook 2, c.1949–51

Ink, coloured wash and pencil on thin white paper: 7 loose sheets from a dismembered sketchbook
30.3 × 44.4 (12 × 17½)
TGA 8421.1.8

These seven sheets came from a group of forty-six. They are closely related to the group of thirty-seven sheets described in the *'Paris' sketchbook 1* (TGA 8421.1.7, above) and are possibly from the same sketchbook. The group of forty-six contains sketches for figures of brass wire and for prints of abstracted figures of 1949, for the cement boy with an owl at Kings Heath Lower School, Northampton, for carved wood figures like the Tate Gallery's 'Figure', 1949 (TO 3866) in yew wood, and the Arts Council's huge 'Apocalyptic Figure', in ash wood, for cut metal reliefs and abstract wire constructions of *c.*1951.

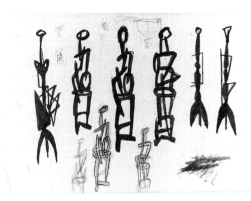

Studies for abstract standing figures, similar to sculptures of 1949–50
TGA 8421.1.8, f.1

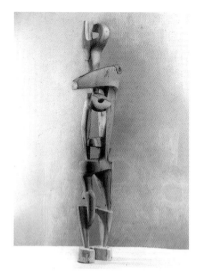

'Figure' 1949 (altered 1951) Yew
99.1 × 22.8 × 22.8 (39⅛ × 9 × 9)
Tate Gallery TO3866 (G.79)

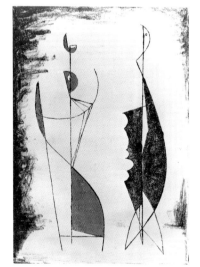

'The Encounter' 1950 Monotype
43.2 × 30.5 (17 × 12) *Museo Civico di Torino, Italy*

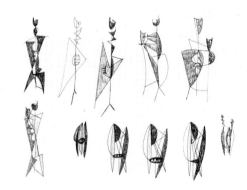

Studies for abstract figures on three-point supports, resembling constructions of brass rod and prints of 1949–51
TGA 8421.1.8, f.4

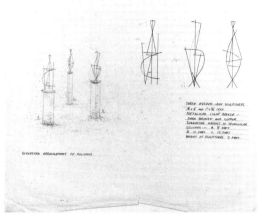

Presentation drawing for scheme for three
enlarged metal figures
TGA 8421.1.9, f.2

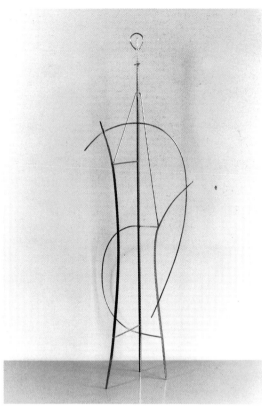

'Standing Figure' 1949 Brass 102.9 (40½)
Morris, London (G.96)

'Presentation', studies, *c*.1952–3

Blue ballpoint, ink and pencil on thin
white paper: 13 loose sheets of
varying sizes
TGA 8421.1.9

This group of thirteen loose sheets of
drawings possibly dates from 1952–3.
The most important of them are several
elaborate presentation drawings
showing a scheme for displaying
enlarged versions of constructions of
abstract figures made in 1949 (see the
Northampton/'Paris' sketchbook, TGA
8421.1.6 above). The original con-
structions of 1949 are made of brass
rod and strip and the largest is forty
inches high ('Standing Figure', private
collection). Annotations on these
drawings show that Adams planned to
enlarge them to seven feet high and to
make them in welded iron. They were
to be displayed as a group either on
high columns or on staging of hexago-
nal formation. So that the iron would
withstand weathering, he indicates that
they should be sprayed with bronze or
copper finishes applied by the firm
Schori Metallising Process.

A quotation of January 1953 for
metallising from this firm, preserved
among Adams's papers in the Archive
(TGA 8421.4.140), perhaps relates to
this scheme and a similar presentation
drawing, in a dismembered sketchbook
in a private collection, is dated 1952.
The scheme to enlarge the sculptures
was not carried out and where Adams
planned to show them is unknown.

Chairs, studies, ?early 1950s

Ink and pencil on off-white paper:
3 loose sheets
20.3 × 25.2 (8 × 9¹⁵⁄₁₆)
TGA 8421.1.10–8421.1.12

Ink and pencil on off-white paper:
2 loose sheets
21 × 33 (8⁵⁄₁₆× 13)
Watermarked: 'BARCASTLE/DUP –
FIRST/BRITISH MADE' with forti-
fied gate
TGA 8421.1.13, 8421.1.14

These five loose sheets have rows of
studies for chairs with metal frames.
The chairs are of advanced design and
include a cantilevered, upholstered
chair, a low, relaxing chair, an upright
chair for office or dining-room and a
slung, hammock, chair. The designs
were probably made when Adams was
at the Central School of Art, where he
taught in both the School of Drawing,
Painting, Modelling and Etching and
the School of Industrial Design. The
principal, William Johnstone, encour-
aged a Bauhaus-inspired fusion of art
and design and Adams himself prac-
tised it. He visited the New Bauhaus
in Chicago at the end of 1950 and at
the Central School he met architect-
designers such as Trevor Dannatt.
Advanced furniture by Dannatt and
Terence Conran was shown with
Adams's sculpture and abstract art by
his painter friends at studio exhibitions
organised by Adrian Heath in 1952–3.
These designs also resemble chairs by
Robin Day of 1950–1 (see *House and
Garden*, vol.6, no.4, May 1951,
pp.24–5). As far as is known, these
designs were not realised but Adams
always maintained an interest in
furniture and towards the end of his
life designed and made at least two low
tables. A design for a low table occurs
in the *Bronzes, Wall-Hanging* sketchbook
(TGA 8421.1.54, below).

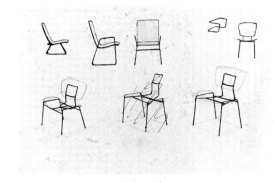

Designs for chairs
TGA 8421.1.13

Constructions, Heads, studies, *c.*1951–4

Black ink and pencil on off-white paper:
3 loose sheets
21 × 33 (8⁵⁄₁₆ × 13)
Watermarked: 'BARCASTLE/DUP –
FIRST/BRITISH MADE' with forti-
fied gate
TGA 8421.1.15–8421.1.17

These three sheets were laid into the
Carving to Welding sketchbook (TGA
8421.1.18, below) and probably date
from *c.*1951–4. They have rows
of studies for two types of sculptures.
The majority have about four stalks,
to be made of wire or rod, which rise
vertically from hemispherical bases and
end in right angle bends or loop back
on themselves. In some of the studies
the rods rise through raised platforms
deriving from the pelvises and shoul-
ders of the earlier abstracted figures.
The other type has a planar, oval or
rectangular, head form, raised on short
stands and pierced by eyes. The first
type bears some resemblance to con-
structions of brass wire made in 1951
but no sculptures like the second type
are known to have been made.

Three studies (top left) for drawings, prints or collages, remainder related to sculptures of 1951–3
TGA 8421.1.18, f.2

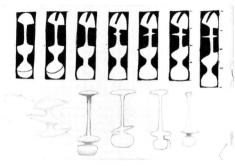

Studies for series of sculptures 'Growing Forms', 1952–3
TGA 8421.1.18, f.7

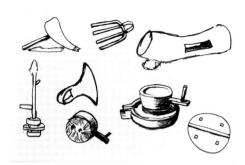

Studies of tools and other artefacts
TGA 8421.1.18, f.12

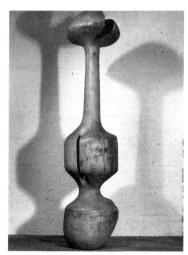

'Growing Forms' 1953 Sycamore 91.4 (36) *Gimpel Fils Gallery* (G.170)

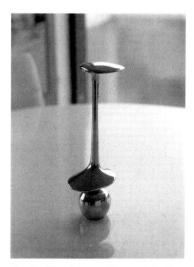

'Growing Forms' 1952–3 Bronze 26 (10¼) Ed. of 5 or 6 *Private Collection* (G.165)

Carving to Welding sketchbook, *c*.1952–7

Pen, pencil and colour wash on cream paper with one perforated edge: 58 sheets and 1 loose insert 25.5 × 39 (10 × 16) Grey cover printed with: ROBERSON'S LAYOUT PAD ..., C ROBERSON & CO LTD, 71 PARK WAY, LONDON, ENGLAND
TGA 8421.1.18

This very full and varied sketchbook was used between about 1952 and 1957 and spans the exciting transition from mature abstract carvings in wood to sculptures in welded steel. Among the abstract carvings for which there are sketches at the start of the sketchbook are the series of small divided columns and divided pillars. Though drawn in outline, these contain a powerful sense of compressed mass and form in the round. There are also several folios of studies for the series titled 'Growing Forms' of 1952–3. In this series Adams made two small bronzes from carved wood patterns, a large wood version and a version in concrete. They are his most Arp-like sculptures and suggest the essence of both human figures and plants. They have rounded, bulbous bases which narrow to waists and swell again to torsos supporting stalk-like necks and flattened heads. The studies are laid out in regular rows. The majority are in ink and emphasise the importance of silhouette, but there are also a few in pencil which indicate the roundness of the forms. Adams had worked in series from an early date but these methodic studies demonstrate most emphatically how he would consider variations on a basic theme until he had drained his overflowing visual imagination.

Following the studies for 'Growing Forms' are several folios of studies of

primitive tools. As a young man, Adams had become familiar with hand tools and mechanical tools when he worked in a timber yard, printer's workshop and agricultural machinery factory and he continued to use them all his life with skill and familiarity. But these studies, unlike those made earlier of his workplace, are of tools entirely removed from a working context. They must have been drawn in a museum where they were displayed as archaeological or ethnographic objects. They are spread out separately over the folio without indication of how or for what they were used. Many are enigmatic *objets trouvés* but all have a strong sense of human scale, of forms made for the hand by the hand. Adams's carved abstract sculptures of this period have similar characteristics.

That tools can be used destructively as well as creatively and that they are potent symbols in Christian iconography is brought home by several drawings which follow, of the crucified Christ and abstract studies of the Stations of the Cross. Adams had become a Roman Catholic on his marriage in 1951 to Patricia Devine, a Dubliner, and his faith was important to him, though he was not a regular attender at church. More research needs to be made on his religious work for it is not well documented. Some commissions from churches evidently came to him soon after his marriage and in about 1955 he made a bronze crucifix for the Bishop of Coventry at the request of Basil Spence. The crucifix is known from a photograph only and remains untraced. Some of the studies here probably relate to this crucifix which is quite naturalistic though simplified, recalling early Christian images and even Russian icons. (A note on folio 1 of this sketchbook refers to a book about Russian icons.) Adams may also have looked at the work of Eric

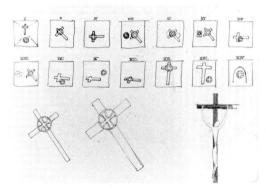

Studies symbolising the Stations of the Cross, studies of the Cross and of Christ on the Cross
TGA 8421.1.18, f.21

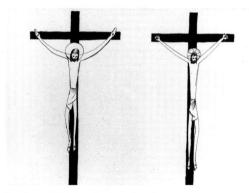

Drawings of Christ on the Cross for a bronze crucifix
TGA 8421.1.18, f.23

Gill. There are two more drawings of the crucified Christ (see ff.1–2 of 'Judgement and Crucifixion' studies, TGA 8421.1.19, below). The studies for the Stations of the Cross are much more abstract and show Adams attempting to imbue his formal language of balanced relationships with religious symbolism.

The studies of tools and religious subjects are followed by several folios containing studies for the series of wood carvings titled 'Counterbalance', a group of which were shown at Gimpel Fils Gallery in February 1956. The 'Counterbalances' are Adams's last wood carvings with the exception of the patterns for bronzes which he continued always to make in wood. They are aptly named, for they have asymmetric, drawn-out, conical limbs, extending far from horizontal 'bodies', shaped like the hulls of boats or aeroplanes, which are themselves balanced on single, slim, conical bases. The series reminds one of Adams's early interest in drawing and sculpting dancers. With the 'Counterbalances' he must have felt that he had reached the

limits of the material he had started to work with over ten years earlier and he turned instead to welded iron and steel.

Poised balance, momentarily frozen, is again strongly expressed in two types of prints made in 1955, titled 'Descending Forms' and 'Rectangular Forms', which Adams also showed at Gimpel Fils the following year. There are a few studies for these prints in this sketchbook and more finished studies on loose sheets (see 'Prints and Collages' studies, TGA 8421.1.20–8421.1.26, below).

The last third of this sketchbook is devoted to studies, drawn in black ink, for sculptures in iron and steel. Already several different types are shown. Developing from the 'Counterbalances' are a group with planes of sheet metal curling together like petals above conical bases. Related to them is another series with a large, single, crescent-shaped plane mounted on a tripod, balancing small triangular planes within its sheltering curve. One of these was shown in 1958 in an exhibition devoted to religious art where it was titled 'Mystical Form'.

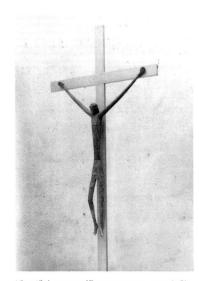

'Crucifix', c.1955 ?Bronze approx. 45.7 (18) *Untraced* (G.195)

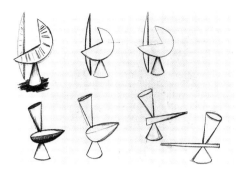

Studies for two abstract sculptures: bottom row relates to the 'Counterbalance' series, 1955
TGA 8421.1.18, f.29

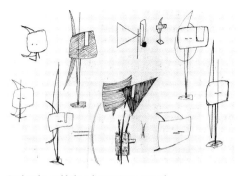

Studies for welded sculptures: top, second from left, is for 'Reacting Curved Form No.2', 1957 (Fundacion Museo de Bellas Artes, Caracas)
TGA 8421.1.18, f.45

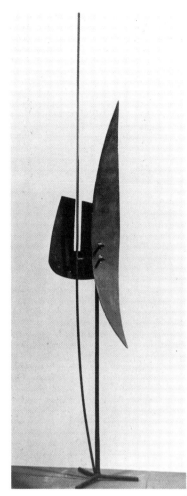

'Reacting Curved Form No.2', 1957 Iron and steel 158 × 39.4 × 38.1 (62½ × 15½ × 13)
Fundacion Museo de Bellas Artes, Caracas (G.213)

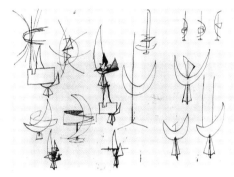

Studies for welded sculptures. Top left relates to 'Curving Movement' series, 1958
TGA 8421.1.18, f.52

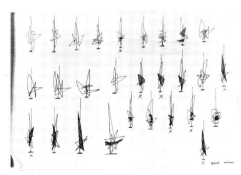

Studies for welded sculptures, c.1957
TGA 8421.1.18, f.55

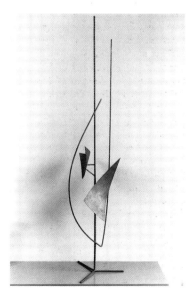

'Two Triangular Forms', 1957 Bronzed steel 140.8 (55½) *Morris, London* (G.211)

[35]

Most common are studies for sculptures with a single vertical rod which supports strongly contrasting planes of sheet metal shaped into crescents, triangles or curving shields. As Adams explained in a contemporary statement, he used metal to express movement (see R. Adams, 'Personal Statement', *Ark, Journal of the Royal College of Art*, no.19, 1957, pp.28–9).

The vertical rod is a stable element around which move contrasting planes of metal sheet or thinner, subsidiary rods. Though these sculptures are still very much conceived in the round, the studies emphasise their open silhouettes. Lines are inscribed to suggest movements in space around the vertical rods. The change in technique released a tremendous surge of ideas. Some of the last folios of this sketchbook show as many as thirty different studies for sculptures.

Judgement and Crucifixion, studies, 1950s

Ink on cream wove paper: 3 loose sheets
25.5 × 21 (10 × 8¼)
Watermarked: BARCASTLE ...
TGA 8421.1.19

These three sheets show Christ on the Cross with head to one side, Christ on the Cross with head looking down, and Christ being led away from Pilate by a centurion on his right and a second figure on his left. See the *Carving to Welding* sketchbook (TGA 8421.1.18, above) for a discussion of Adams's religious work.

Prints and Collages, studies, 1954–5

Pencil, ink and black crayon on fragments, a variety of papers:
10 loose sheets
TGA 8421.1.20–8421.1.26 are studies for prints; TGA 8421.1.20 is on writing paper from the Central School of Art and is dated 31 March 1953; TGA 8421.1.26 has an inscription on the verso '*Herculite, Mathews, Euston Road*'. They vary in size. TGA 8421.1.27–8421.1.29 are studies for collages and all measure 20.4 × 25.4 (8¹⁄₁₆ × 10)
TGA 8421.1.20–8421.1.29

These small studies can be related to collages and prints of 1954–5. Though small, they are lively, and show the care with which Adams built up compositions of abstract forms to suggest natural movement. He showed two collages (private collections) in January 1955, at the exhibition *Nine Abstract Artists*, composed of segments of circles which tumble across and down the rectangular sheets. Studies here show that the apparent casualness of these movements, like those of leaves or pebbles in a stream, was only achieved after careful experiments in placing the forms in relation to each other. With the studies for tumbling segments of circles are others (TGA 8421.1.27–8421.1.29, below) in which the segments are arranged parallel to each other, straight side contrasting with curve, in blocks. The blocks are marked with regular divisions where the thin segments meet. Collages survive in the Tate Gallery Archive which relate closely to these more geometric studies (TGA 8421.2.1–8421.2.2).

At an exhibition of recent work at Gimpel Fils in February 1956 Adams showed four prints of 1955 titled

Study, similar to 'Rectangular Forms', 1955
TGA 8421.1.22

'Descending Forms', 1955 Engraving
38 × 17.8 (15 × 7) Ed. of 25
Morris, London

'Rectangular Forms', 1955 Engraving
29.2 × 22.9 (11½ × 9) Ed. of 25 *Morris, London*

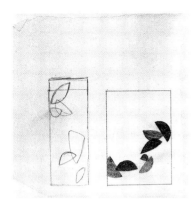

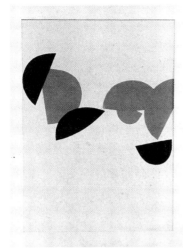

Studies for collages or prints
TGA 8421.1.23

'Moving Forms', 1954 Collage 33 × 44.4
(13 × 17½) *Private Collection*

'Descending Forms' and 'Rectangular
Forms' (copies at Gimpel Fils). In
'Descending Forms' a tall, narrow,
outlined rectangle frames a composition
with an off-centre, slightly serpentine
vertical line, around and down which
float irregular segments of circles. The
fall of the forms is natural, like that of
leaves, but the studies show that this
was only achieved after many minute
adjustments. The vertical line is moved
more to one side, the segments are
reduced in number and their outlines
made to follow each other down the
composition. The studies for 'Rectangu-
lar Forms' show Adams positioning
floating quadrilaterals to achieve a
tense equilibrium in the print. In the
studies, their proportions and move-
ments are clumsy, while in the print
they are poised precisely and delicately
against each other.

Gelsenkirchen sketchbook, c.1956–61 (majority c.1957)

Pencil, pen, black crayon on white
bank paper: 41 sheets, many of which
are loose and some laid in
44 × 28.3 (17½ × 11⅛)
Grey cover, printed: ROWNEY
Series 91, Artists' Layout Pad
TGA 8421.1.30

This sketchbook is confused, as many
of the studies are on loose sheets of
paper which have been laid in without
regard for chronological order. The
studies were made for a variety of
widely different projects, from small
religious sculptures to large architec-
tural commissions. Among the studies
for architectural sculpture are several
for the relief in reinforced concrete for
the city theatre of Gelsenkirchen in
Germany. Adams was already known
in Germany before the 1952 Venice
Biennale as one of the most promising
young British sculptors and in 1957 he
had a one-man exhibition which began
in April in the avant-garde Galerie
Parnass in Wuppertal and toured to
Dortmund, Bonn and Düsseldorf. He
may have met then the German
sculptor Norbert Kricke who, like
Adams, suggested kinetic rhythms in
sculptures of welded metal rods
and who led one of the teams of
artists invited to compete to provide
art for the planned new theatre at
Gelsenkirchen. On 16 July 1957
Kricke wrote to Adams asking him to
contribute a maquette for a relief for
the theatre: 'on the wall of the cashier's
office. It is the main entrance ... the
focal position on the building's exterior
and what is needed is a contrast to the
light glass facade – a *compact, rhythmi-
cal* solution perhaps in dark stone
or coloured cement' (see TGA
8421.4.66). The maquette of plaster
had to be completed by 30 August

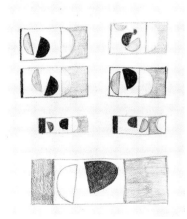

Studies for a collage
TGA 8421.1.28

1957 and the entries were judged and on display by 15 December 1957. The theatre was opened in December 1959. It is a Miesian building of steel and glass designed by Werner Ruhnau, who believed firmly in the collaboration of architects, painters and sculptors. As well as Adams and Kricke, Yves Klein, Jean Tinguely and Paul Dierkes contributed.

Adams's relief is very large, it measures 9 × 72 feet, and it anchors the facade to the ground. After considering a composition of floating planes, he settled on a more stable one with heavy, interlocked, U-shaped forms adapted from a bronze 'Maquette for an Architectural Screen', which he had shown at Gimpel Fils in February 1956 (cast in the Tate Gallery, T00906). Slanting planes are linked to create a marching rhythm across the relief. Adams always regarded the Gelsenkirchen relief as his most successful architectural work.

He used a composition of floating planes in another architectural commission of 1957 for which there are also many studies in this sketchbook – a concrete relief, 20 × 5 feet, on the outside wall of the Drama Hall at the London County Council's new Eltham Green School. (See W.J. Strachan, *Open Air Sculpture in Britain*, 1984, p.45.) The studies show that he began with interlocked, rectangular forms, similar to those at Gelsenkirchen but changed to a composition of floating, wedge-shaped planes which descend the panel in a serpentine curve. As with the Gelsenkirchen relief, he adapted the composition from a small bronze relief shown at Gimpel Fils in February 1956 (private collection). The studies show him refining this composition, reducing the number of planes and slightly altering their positions in relation to each other. He also carefully considered the proportions of the relief to that of

Studies for architectural reliefs: above, possibly for Gelsenkirchen City Theatre; below, for Queen's Gardens, Hull
TGA 8421.1.30, f.1

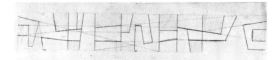

Study for relief at Gelsenkirchen City Theatre, 1957
TGA 8421.1.30, f.2

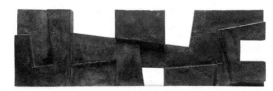

'Maquette for Architectural Screen', 1956
Bronze 21.6 × 74.9 (8½ × 29½) Ed. of 6
(G.184) (See also fig.5 on p.15)

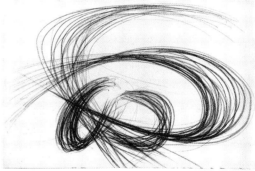

Swirling sheaves of lines related to Norbert Kricke's studies of movement
TGA 8421.1.30, f.9

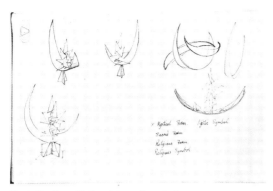

Six studies for welded sculptures: four studies are for 'Mystical Form', 1957–8
TGA 8421.1.30, f.16

Two preliminary studies for relief at Eltham Green School, 1957
TGA 8421.1.30, f.18

Studies for relief at Eltham Green School, 1957
TGA 8421.1.30, f.25

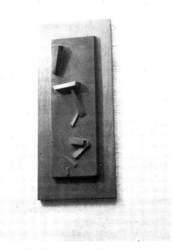

'Descending Forms', 1954 Bronze 22.9 × 7.6 (9 × 3) Ed. of 6 (G.174)

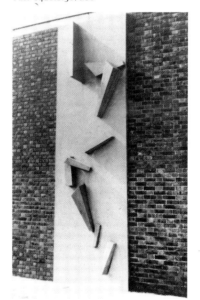

'Descending Forms', 1957 Reinforced concrete 609.6 × 152.4 (240 × 60) Eltham Green School, London SE9 (G.221)

the whole wall upon which it is placed. It is positioned off-centre with areas of dull red brick on either side. A finished design with collage, in a private collection, shows the relief on the whole end wall.

In June 1958 Adams won a limited competition for a large relief in Portland stone, 5 ft 3 in × 35 ft 6 in, for Queen's Gardens, Hull. Studies for this relief are found close to those for the Gelsenkirchen theatre and Eltham Green School. For Hull he used an undulating wave of wedge-shaped planes, similar to those in the Eltham Green relief, but running horizontally. The relief in Queen's Gardens faces a reflecting pool and the composition of the planes echoes the pattern of jets of water thrown out from the base of the relief into the pool.

Several folios of studies are laid into this sketchbook which were made later, in 1961, but as they are also for an architectural decoration they may be mentioned here. They are for a long wall panel on the P&O liner *S.S. Canberra*. In the studies, Adams evolves a fan-shaped composition of rays which were to be made up of slats of wood lit by a raking light. The motif perhaps relates to the Orient or to the name of the tourist class lounge, the Peacock lounge, for which the decoration was intended. Adams also designed a large suspended ceiling for the lounge and there is a study for this which is discussed in a later entry, *S.S. Canberra*, studies (TGA 8421.1.32–8421.1.39). According to Stephen Rabson, Librarian at P&O, the architect in charge was John Wright; the decoration and ceiling are no longer in position.

Other architectural studies in the sketchbook are more utilitarian, being plans for alterations to his home in Pilgrims Lane, Hampstead, where he lived from 1953 to 1969. Here he had

converted a large potting shed to provide accommodation for himself and his wife. The plans are for a studio and new entrance.

Amongst the drawings for architectural schemes this sketchbook also contains a few quite different folios of studies for metal religious sculptures. One of these sculptures is the crescent-shaped 'Mystical Form', studies for which occurred in the *Carving to Welding* sketchbook (TGA 8421.1.18, above). The folio is inscribed: 'Mystical Form/Mystic Symbol/Sacred Form/Religious Form/Religious Symbol'.

Another folio has six black ink studies for the bronze sculpture ' The Thorns' of 1958 (61 inches high, one cast at Gimpel Fils, at least two others in private collections). 'The Thorns' is similar to contemporary sculptures in iron and steel. A cluster of sharply pointed barbs curl around and contrast with, a slim vertical spine. Adams himself described it (in a notebook in a private collection) as: 'an attempt to amalgamate in one complete form the Cross, the Crown of Thorns, and the Spirit of Life thrusting upwards'.

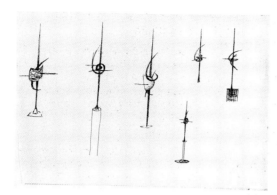

Studies for sculpture 'The Thorns', 1958
TGA 8421.1.30, f.27

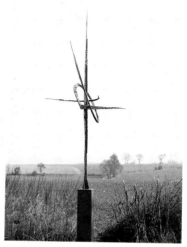

'The Thorns', 1958 Bronze 153.7 (60½) Ed. of 3 (G.259)

Studies for welded sculptures, similar to wall-hung sculptures of 1960
TGA 8421.1.31, f.7

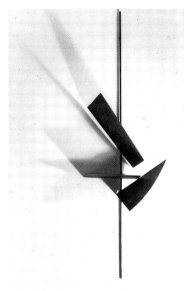

'Three Planes'. 1960 Bronzed steel 153 (60¼) *Gimpel Fils Gallery* (G.321)

Movement in Metal, studies, *c.*1958–60

Pencil on unbound, off-white paper: 12 sheets
33 × 21 (13 × 8⁵⁄₁₆)
Watermarked: 'BARCASTLE/DUP – FIRST/BRITISH MADE' with a fortified gate
TGA 8421.1.31

This group of loose sheets show studies which can be related to sculptures of welded steel shown at Adams's one-man exhibition at Gimpel Fils Gallery in September 1960. His use of planes and lines of metal to suggest energy and to convey a sense of dynamic movement by contrast was shown vividly in this exhibition. In these studies he angles curved planes against rectangular ones, cuts straight lines through elliptical clusters. The contrasting planes are sometimes mounted clear of the ground on single vertical rods or an tripods, but there are also several studies for wall-hung works. At Gimpel Fils in September 1960 he showed eight large wall-hung sculptures, with six maquettes. These wall sculptures rely on a single, dominant, vertical rod as a foil to three clustered planes. The planes, which are triangular, rectangular or with curved edges, are angled against one another so that they counterbalance each other's suggested movement away from the rod. In the studies, the clusters of planes are complicated and lack the controlled sparseness found in the sculptures.

S.S. *Canberra*, studies, *c.*1961–4

Pencil and green ink spray on thin off-white paper: 6 sheets, and cut-out card: 2 sheets
Paper: 28.3 × 66.4 (11¹⁄₁₆ × 26) (1 sheet); 40.3 × 50.5 (15¹⁵⁄₁₆ × 19¾) (5 sheets); card: 30.4 × 28.4 (12 × 11³⁄₁₆); 28.3 × 13.5 (11⅛ × 5¼)
TGA 8421.1.32–8421.1.39

This group of six large sheets of studies in pencil and two designs cut into card can be related to Adams's commission of 1961 for the Peacock lounge in the P&O liner, *S.S. Canberra*. Some of the group may also be preliminary ideas for a gate commissioned in 1964 for a house in Dallas and for a large screen of the same date for Sekers Textiles Showrooms at 190–2 Sloane Street in Knightsbridge. None of these commissions remain *in situ*.

As mentioned in a previous entry (TGA 8421.1.30), Adams designed a wall decoration with a composition of spreading rays, perhaps referring to the Orient or to a peacock's tail, for the Peacock lounge in *S.S. Canberra*. He also designed a suspended ceiling for the same room and the largest of these loose sheets, made up of two sheets stuck together, carries a drawing for the ceiling. It has the same radiating fan motif as the wall decoration but the composition is more involved. Triangular spreads of rays are juxtaposed in kaleidoscope formation over an area which was to measure 43 × 17 feet. Like the wall decoration, the ceiling was erected but seems to have been removed after only a short time.

He probably also designed screens for the liner and some of the studies on the other sheets and the designs cut into cards may be for these screens, which do not seem to survive nor to have been photographed. Or the studies may be ideas for the Dallas gate or the screen for Sekers.

Some of the designs have spreading fan patterns, contained within rectangular outlines, which are similar to the ceiling design but for smaller areas, appropriate for a single screen or gate. One sheet has a bold cluster of white triangles standing out from a dark pencil surround. The triangles float together and apart like fish in a shoal. Similar compositions of triangles are found in lithographs which Adams exhibited at Gimpel Fils in November 1962. (Tate Gallery P06001, P06003, and in the Scottish National Gallery of Modern Art, Edinburgh.) There are also studies for screens, or possibly a gate, composed of ranks of narrow slats, stacked vertically or horizontally, in pleated formation. Other designs, again for screens or a gate, have streams of needle-like lines, terminating in little circles, which flow through rectangular compartments as though under magnetic force.

Closely related to the last designs mentioned above are two designs cut into card sprayed with green ink so that it has a mottled finish. One card is scored to be pleated and appears to be a finished maquette for a screen. The other is unfinished. The flowing patterns of lines are fully revealed when the cards are held against the light. They would have made successful screens but whether they were realised is not known. The Sekers screen has linear rods and thin slats but arranged in rows rather than flowing streams. (See TGA 8421.1.40, below)

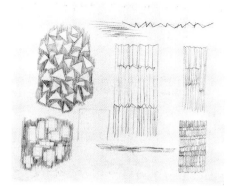

Studies relating to early 1960s lithographs and for a pleated screen
TGA 8421.1.32

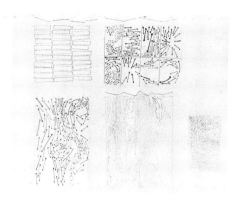

Designs probably drawn in connection with a screen for *S.S. Canberra* or Sekers Textile Showrooms
TGA 8421.1.33

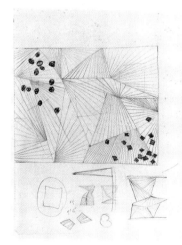

Compositions of rays, probably drawn in connection with a screen for *S.S. Canberra* or the Dallas gate
TGA 8421.1.34

Study for a suspended ceiling for *S.S. Canberra*
TGA 8421.1.37

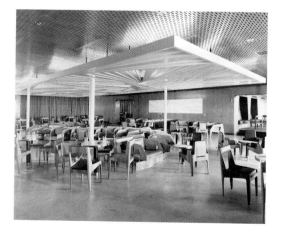

Suspended ceiling and wall panel for the Peacock lounge, *S.S. Canberra*, c.1961
Painted wood, ceiling 1310.6 × 518.2 (516 × 204) *Removed* (G.355)

Studies for sculpture at 24 Cathcart Road,
Fulham, London, 1963
TGA 8421.1.40, f.4

Drawing of facade of Cathcart Road
TGA 8421.1.40, f.13

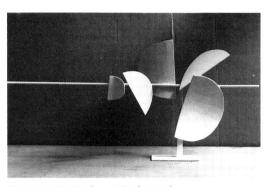

'Forms on a Bar No.1', 1963 Steel sprayed
with aluminium, length 48.3 (19) *Private
Collection* (G.441)

Cathcart Road sketchbook, 1963–6

Pencil and ink on thin white bank
paper: 41 loose sheets including
2 small sheets laid in after page 17
25.3 × 40.5 (10 × 16)
Grey/blue cover, printed: WINDSOR
& NEWTON SWIFT LAY-OUT PAD
SERIES 47
TGA 8421.1.40

The majority of studies in this sketch-
book are for an architectural commis-
sion of 1963 for a sculpture on a house
at 24 Cathcart Road, London SW10.
The house, designed by Timothy
Rendle, has a flat roof and a largely
glazed facade with a pronounced
orthogonal composition of aluminium
window frames. Outside the windows,
at first floor level, is a projecting ledge
which was planned from the start as a
site for a sculpture. Adams produced a
sculpture which relates to the facade in
its material, aluminium, but contrasts
sharply in its form, for it consists of
three clustered planes which are
segments of circular discs. The studies
in this sketchbook show the care he
took to relate the curved edges of the
planes and their scale to the rectilinear
facade. To begin with he arranged a
sequence of five or more segments of
circles around a horizontal bar on a
vertical stand and maquettes were
made of this composition (private
collections).

The sequence was then refined to
three linked segments, poised upright
on their tips, with varying widely
curved radii. Unfortunately the sculp-
ture is no longer *in situ*.

There are also a few studies for
another architectural commission, a
screen and door-handles for Sekers
Textiles Showrooms at 190–2 Sloane
Street, Knightsbridge, which were made
in 1964. The screen, removed in 1990,

was designed to separate the staircase from the ground floor and basement showrooms. It is built up from horizontal rows of rhythmically spaced, vertical tubes and rectangular planes. The door-handles have also been removed.

Other studies in this sketchbook are for sculptures exhibited in 1966. There is a series of studies for almost circular and rectangular reliefs of painted wood, four of which were shown at Gimpel Fils in October 1966. Their overall shield-like shapes are balanced within by firmly struck curves and straight, incised radial lines. Similar bold contrasts of rounded and rectangular planes are found in other studies for a long architectural screen. The intended site for this has not been identified, but it was probably for the New Custom House at Heathrow. Related drawings occur in the *Gimpels '66 and '68* sketchbook (TGA 8421.1.44, below).

Finally there are studies for smaller screens, with large rectangular planes held upright between slim, orthogonal supports. These screens, the most important of which was shown at Battersea Park in the summer of 1966, are to be viewed primarily from the front or back, against the light. Their dark planes are cut into with contrasting vertical or horizontal slits and chains of drilled holes. Similar themes occur in the *Gimpels '66 and '68* sketchbook (TGA 8421.1.44, below).

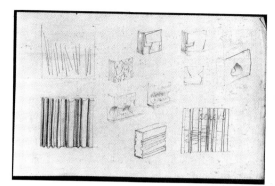

Studies for screen and door-handles for Sekers Textile Showrooms, Sloane Street, London, 1964
TGA 8421.1.40, f.6

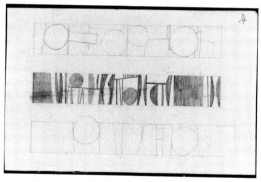

Studies for an architectural screen
TGA 8421.1.40, f.34

Screen Forms sketchpad, ?c.1964

Ink on lined white paper: only 5 sheets with sketches
10.8 × 8.7 (4¼ × 3½)
Cover, printed: WINFIELD SCRIB-BLING PAD
TGA 8421.1.41

There are five sheets of slight, outline sketches in ink in this small pad. They are difficult to relate to existing sculptures but can perhaps be connected to the series of screen forms of the mid-1960s. These sculptures have large, rectangular, single planes broken by vertical slits from the top edge and pierced by chains of drilled holes.

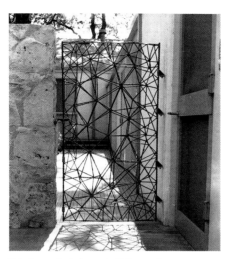

Gate for a private house in Dallas, 1964
Bronze 146 × 85.1 × 17.1
(57½ × 33½ × 6¾) *Mr and Mrs Michael A.*
Roberdeau Dallas, Texas (G.457) (photo:
Michael Morris)

Dallas sketchbook, *c.*1964–5

Pencil, coloured crayon and pen on
thin white bank paper: 18 loose sheets
40.5 × 25.4 (16 × 10)
Grey/blue cover, a fragment
TGA 8421.1.42

This sketchbook now consists of loose
sheets, a cardboard back and fragment
of grey/blue cover, which is similar to
the colour of the cover on the Windsor
and Newton Swift Lay-Out Pad (TGA
8421.1.40, above). The sheets are
probably not in their original order.
 Many of these loose folios are studies
for a gate commissioned by the Dallas
patrons James and Lillian Clark in June
1964. The gate had to fill a space
between their house and a garden wall.
It measures '58 in × 33 in × 7 in' and
is built up from short bronze rods
joined in cellular clusters. They make
two webs which are '7 in' apart in
the centre and come together at the
vertical sides. The spaces between
the rods vary in size, growing larger
towards the centre of the webs. The
forms are very organic, resembling
natural growth such as plant tissue
observed through a microscope. The
studies here show Adams experiment-
ing first with other related forms which
suggest strata of friable rock or shoals
of leaves.
 There are also several studies for an
elaborate fountain, together with notes
about the movement of water. Water is
drawn falling from ledge to ledge and
through a wheel in one open construc-
tion, or forced through a cellular
column to be made of clear Perspex, or
cascading from a tower with hexagonal
openings. These studies can possibly be
connected with a commission Adams
received in June 1965 from the Greater
London Council to work with the
landscape architect Sylvia Crowe on
a monumental sculpture, possibly
incorporating a water feature, at
the north entrance of the Blackwall
Tunnel. This scheme foundered in the
following year. There are more devel-
oped studies for it in the *Gimpels '66
and '68* sketchbook (TGA 8421.1.44,
below).

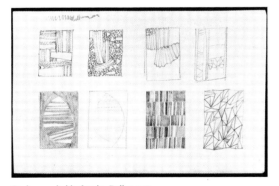

Studies, probably for the Dallas gate
TGA 8421.1.42, f.11

Studies for the Dallas gate
TGA 8421.1.42, f.15

Standing Screen study,
*c.*1964–5

Ink on off-white thin paper: single sheet
20.3 × 11.6 (8 × 4⁹⁄₁₆)
TGA 8421.1.43

See the next entry (TGA 8421.1.44).

[45]

Gimpels '66 and '68 sketchbook, *c*.1965–8

Pencil, ink and coloured crayon on thin, white bank paper: 63 sheets
44.2 × 27.9 (17½ × 11)
Cream cover, printed in red: DALER LAY-OUT PAD
TGA 8421.1.44

During 1965–8 Adams was producing his largest and most minimal sculptures in sheet steel. They have broad, flat planes with straight or regularly curved edges. Many designed in 1965–6 are in screen form, to be seen from front or back, while those made in 1967–8 have planes juxtaposed orthogonally, giving more depth and encouragement for all-round viewing. The first few folios of this sketchbook have a series of careful studies for two large horizontal screens constructed from rectangular, plank-like segments of metal sheet with occasional, contrasting, circular forms. They are probably preliminary studies for screens for the entrance to the New Custom House at Heathrow Airport for which Adams was commissioned in April 1965. They were erected in 1967. Their proportions are the same as in these studies though the forms are quite different.

 Several following folios have sketches for another architectural commission, given by the Greater London Council in June 1965, which came to nothing. Adams was asked to work with the landscape architect Sylvia Crowe to provide a monumental sculpture, with possibly a fountain, on a two-acre site at the north entrance of the Blackwall Tunnel. (See also the *Dallas* sketchbook, TGA 8421.1.42, above.) He planned a sculpture of three massive slabs arranged in a pinwheel formation on a slight hillock. This was a sculpture to be walked around and the sketches

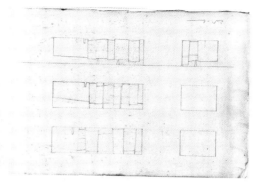

Studies for architectural screens at Heathrow
TGA 8421.1.44, f.1

Study for unfulfilled Blackwall Tunnel sculpture project, 1965–6
TGA 8421.1.44, f.16

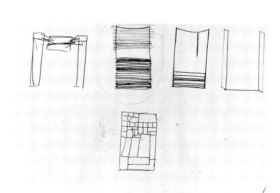

Study for 'Screen with Slats' (1965–6) (third from left) and for related 'Screens'
TGA 8421.1.44, f.7

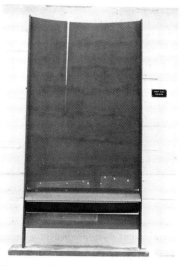

'Screen with Slats', 1965–6 Bronzed steel
165.1 × 96.5 × 20.3 (65 × 38 × 8)
Private Collection, USA (G.498)
(photo: Michael Morris)

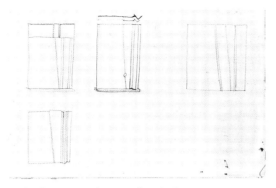

Studies for 'Screen with Diagonal', 1965–6
TGA 8421.1.44, f.27

Studies for the screen for Adams's house, 1965
TGA 8421.1.44, f.28

Studies for 'Folding Movement' made in
1975–6 for Williams & Glyn's Bank
TGA 8421.1.44, f.31

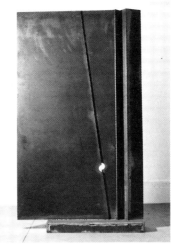

'Screen with Diagonal', 1966 Bronzed steel
128.3 (50¼) *Gimpel Fils Gallery* (G.499)

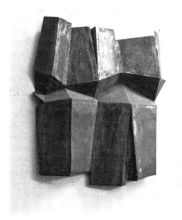

'Maquette with Folding Movement'. *c.*1965–6
Steel approx. 20.3 × 30.5 (8 × 12) *Untraced*
(G.497) (photo: Michael Morris)

show how Adams planned it as the focal point of its landscape setting. The scheme was dropped in 1966 but the sculpture titled 'Trio', shown that year at Gimpel Fils, is related to it and this was bought as a garden sculpture by the Dallas patrons, James and Lillian Clark.

As already mentioned, in 1964 Adams had designed a gate for the same patrons and this sketchbook contains studies for a screen which develops from it, intended for the sculptor's own home in Hampstead. This screen survives but has been removed from the place for which it was designed. (Gimpel Fils.) Both gate and screen are formed from a double web built up from short lengths of rod joined in cellular formation. The cells grow larger towards the centre of the webs. The sense of organic growth is very strong.

Adams's other screens of this period are made from steel sheet and are much more opaque. Light is blocked out, apart from thin lines and chinks. The position and size of the apertures are carefully calculated to balance and contrast with the dark bronzed steel. Adams wanted these screens placed frontally before white, well-lit walls. This was done when one of the most impressive of them, 'Screen with Slats' (private collection, USA), was shown at Battersea Park in the summer of 1966. There are studies for this screen in this sketchbook with the light and dark reversed. The steel sheet is a white plane pierced with dark, contrasting, vertical and horizontal cuts and a decorative line of dark holes. Vertical slats frame it at either side, at the base are horizontal, parallel bands of slats broken by chains of small holes. If it were not so elegant, it might be related to paintings by Clyfford Still or Barnett Newman. (See TGA 8421.1.43, above.)

Adams stopped making large sculp-

tures of metal sheet abruptly in 1968 and turned to small works in chromed steel and then in marble. He ground parallel grooves and scallops into the flat faces and edges of rectangular steel blocks and carved the marble similarly, using subtractive techniques which were quite unlike those he had employed since he had ceased carving in wood in 1955–6. The studies for these new sculptures, first shown in a series of chromed-steel reliefs at Gimpel Fils in September 1968, show more concern for three-dimensional form than the studies earlier in the sketchbook for screens. The blocks are drawn in three-quarter view, presenting flat faces and sides rhythmically modulated by parallel grooves.

At the end of this sketchbook, immediately following the studies for carved steel sculptures, are several folios of careful studies of leaves, twigs and grass stems. They record the crinkly edges of leaves and the way they fold over in space. Curving edges contrast with straight, branching stems. Strange protruberances swell out around a forked tree branch. The unexpected, three-dimensional forms of natural growth were clearly an inspiration to Adams in his sculpture, though his sculpture is never naturalistic. In an interview published in 1969 he remarked on his sudden return to drawing from nature, which he dated to time spent at his country cottage in Essex two years before: 'It was marvellous. I suddenly started drawing like mad – trees, roots, old stumps that had begun to shoot again – I made dozens of drawings, filled my sketchpad and finished in a writing pad.' (I. Mayes, 'Robert Adams', *Sculpture International*, vol.2, pt.4, April 1969, p.8.)

Studies of leaves
TGA 8421.1.44, f.56

A Move? sketchbook, 1968 or 1971

Blue ballpoint and pencil on thin white paper: 9 sheets with notes and sketches, rest blank
40.6 × 25.4 (16 × 10)
Blue cover, printed: WINDSOR & NEWTON SWIFT LAY-OUT PAD SERIES 47
TGA 8421.1.45

This sketchbook contains only one slight study for an unrealised sculpture, but is interesting otherwise as a record of a proposed move to Cornwall during a time of unsettlement. In 1953, Adams and his wife had settled at 2a (now 2b) Pilgrims Lane, Hampstead, where he both lived and worked. Ten years later they adopted a daughter Mary, and in 1965 Adams moved his studio to Primrose Hill. This does not seem to have been a satisfactory space and he searched in vain for a new studio in North London. Letters in the Tate Gallery Archive reveal the frustration of his search. Other letters, dating from early 1968, show that he and his wife seriously considered moving to live in Cornwall. They looked at property for sale on Porthmeor beach, St Ives and elsewhere in Penwith. But in 1969, instead of moving to Cornwall, they bought a large house at 1 Rosslyn Hill, Hampstead and Adams had a studio built there. They seem to have over-reached themselves financially and in 1971 they had to sell the house and move to a country cottage in Essex which they had bought in 1958. This sketchbook contains a list of reasons, which they drew up, for and against moving from London to either St Ives or Essex. Adams gives the advantages of the Essex cottage as being near London, having space, peace, 'trees and things growing' and a '10 ft tall feeling'. The advantages of St Ives were

an exciting flat on Porthmeor beach, the sea, the potentialities of a large studio in an old chapel at Morvah. The disadvantages were mainly that it was a long way from London. His wife, Patricia, also gives her reasons for and against moving to Cornwall and the needs of their young daughter Mary are considered.

Adams had been making regular summer visits to St Ives since the early 1950s and had many friends in the artists' community. In the mid-1970s he did move to St Ives to live, but was not happy and returned to his Essex cottage. The rise in London property prices meant that he could never return permanently to Hampstead.

'Straus' Screen study, c.1969

Pencil on paper: single sheet
25.2 × 20.5 (9^{15}⁄₁₆ × 8^{1}⁄₁₆)
Inscribed, top left: Straus screen
TGA 8421.1.46

Adams made a bronzed steel screen for Gerhard Straus of Milwaukee, USA, in 1969.

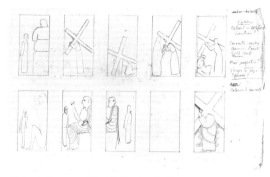

Abstracted scenes of Christ's Passion for the
reliefs intended for Clifton Cathedral, Bristol
TGA 8421.1.47, f.8

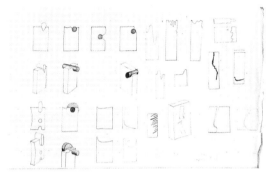

Studies for marble sculptures of 1970
TGA 8421.1.47, f.14

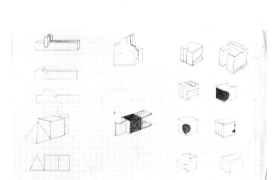

Studies for carved sculptures of basic forms
TGA 8421.1.47, f.15

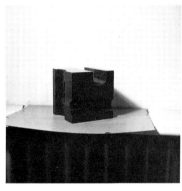

'Cube', 1970 Granite 15.2 × 15.2 × 15.2
(6 × 6 × 6) *Gimpel Fils Gallery* (G.589)

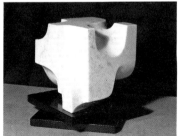

'Marble 7 (Cube)', 1970 Sicilian marble
17.8 × 17.8 × 17.8 (7 × 7 × 7)
*The James H. and Lillian Clark Collection,
Dallas, Texas* (G.585)

Marble sketchbook, *c.*1969–70

Pencil and blue ink on thin white bank
paper: 22 sheets
44.4 × 27.6 (17½ × 11)
Pink cover, printed: DALER LAY-OUT
PAD
TGA 8421.1.47

This sketchbook was used *c.*1969–70,
after Adams had abandoned large-scale
sculptures in welded steel and turned to
smaller works which he carved. (There
is another, similar Daler Lay-Out Pad
sketchbook in a private collection,
which contains nine sheets with studies
for chromed steel sculptures such as
'Square Minus' and 'Block I', 'Block II',
and 'Block III' of 1969.) The sketches
show that he is now strongly con-
cerned with variations on basic, three-
dimensional forms – cube, cylinder,
triangular wedge. There are studies for
a series of chromed steel blocks with
rectangular bodies modified by nibbled
edges or knobby protruberances rem-
iniscent of the gnarled branches in the
previous sketchbook. There are also
studies for many of the ten or so
carvings in Sicilian marble or stone,
which were made in 1970. These
studies in pencil are small-scale,
precise, delicately shaded and show
the intended sculptures in front, back
and three-quarter views, which make
them very real. Such a precise tech-
nique had not been used before in his
studies for sculpture and accords with
his change in materials. Sicilian marble
is a light cream colour with grey veins.
Some studies show inlays of darker
materials, such as lead, and some slabs
have black cylindrical insertions
projecting from the marble slab.
Modifications to the slab always make
it asymmetric. Examples are the many
studies for one of Adams's largest
marble carvings, 'Marble No.5'
(38 inches high, Gimpel Fils), which
is a rectangular slab with a big

swelling, a growing point, at one side of its top edge. The series of studies show him experimenting with the size of the swelling and end with a full-scale outline profile of its curve, see TGA 8421.1.49–8421.1.51, below.

This sketchbook also contains several pages of studies for reliefs of the 'Stations of the Cross'. These were intended for the new Roman Catholic Cathedral at Clifton, Bristol, but according to the architect Ronald Weeks the commission was cancelled before it got very far. The material was to be concrete. The sequence begins with a page carrying a written description of Christ's Passion from His condemnation to death until His entombment and resurrection. In the following studies Adams experiments with the scenes drawn in varying degrees of abstraction. Some are quite representational while in others the stages are symbolised by an abstracted cross or rays of light. They are worked on as a unified sequence in a series of drawn rectangles arranged in lines across the page. The divisions of the rectangle made by the tilted cross are an important part of each composition. Though not carried out at Clifton, the cross-shaped composition within a rectangular field occurs in some of Adams's later bronzes.

? Flowers study [n.d.]

Blue ink on writing paper with printed heading: PATRICIA ADAMS/I ROSSLYN HILL/HAMPSTEAD NW3 01 435 9617: single sheet
25.5 × 20.2 (10 × 8)
TGA 8421.1.48

The Adamses lived at the address printed on the letter-head between 1969 and 1971.

Large Marble study, c.1970

Pencil on thin white paper: single sheet
25.5 × 20.5 (9^{15}⁄₁₆ × 8^1⁄₁₆)
Inscribed with the measurements
3' × 2'6" × 4"
TGA 8421.1.49

'Marble No.4' working drawing, 1970

Pencil on thin white paper: a single sheet which has been folded
44.2 × 27.7 (17⅜ × 11)
Stamped top left, 'ROBERT ADAMS/ I. ROSSLYN HILL/HAMPSTEAD/ LONDON NW3' and inscribed in ink 'W 5955/*all faces polished/BLOCK 2" thick/12" × 8"'
TGA 8421.1.50

'Marble No.6' study, 1970

Pencil on thin white paper: single sheet
27.7 × 22.1 (10^{15}⁄₁₆ × 8¾)
Inscribed top right: 2" = 1'
TGA 8421.1.51

These three loose sheets show studies for three sculptures of 1970 and they may have been removed from the *Marble* sketchbook 1969–70 (TGA 8421.1.47, above).

TGA 8421.1.49 shows two full-face studies and a plan view for a large marble sculpture which remains untraced. A photograph of Adams working on this marble carving was included in his retrospective exhibition at the Camden Arts Centre, in 1971.

'Marble No.4' was shown at the Camden Arts Centre in 1971 but its whereabouts is unknown. TGA 8421.1.50 is a full-scale working drawing.

The work 'Marble No.6', to which TGA 8421.1.51 relates, remains untraced.

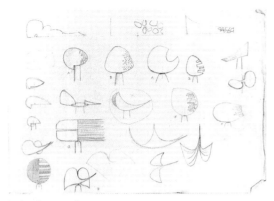

Studies for a weathervane, c.1970
TGA 8421.1.52, f.1

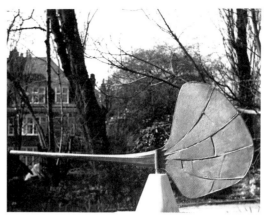

'Weathervane', 1970 Bronze, length 111.8
(44) *Private Collection* (G.586)

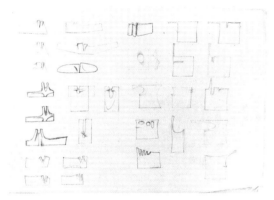

Studies for small marble and bronze
sculptures, 1970-1
TGA 8421.1.52, f.6

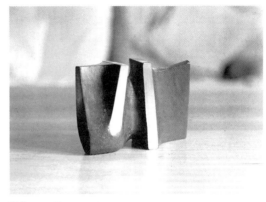

'Col', 1972 Bronze 10.1 × 14 × 5.7
(4 × 5½ × 2¼) Ed. of 6 + 0 (G.608)

'Vertex' Series sketchbook, 1970–3

Pencil, ink, felt tip, crayon on white
paper: 42 sheets, many loose and laid
in 42 × 29.5 (16½ × 11¾)
Black cover, printed in white: DALER
LAY-OUT PAD A3
TGA 8421.1.52

This sketchbook was used *c*.1970–3,
when Adams moved into his last period
of works in bronze and stainless steel.
It contains studies for many of the
small bronzes exhibited at Gimpel Fils
in 1974, his first exhibition there since
1968 when he had shown his last
sculptures in sprayed steel. There are
also studies for the 'Vertex' series of
large, polished, stainless-steel sculptures
and for an ambitious architectural
project.

The bronzes begin with a commis-
sioned weathervane of 1970 (private
collection). The first two folios of
studies show Adams experimenting
with a variety of fin-like forms for this.
Eventually he settled for a leaf-shaped
blade tapering to a long, pointing stem.
Many of the bronzes which follow also
have forms which resemble those in
nature. Their titles reinforce associa-
tions with landscape or seascape:
'Col', 'Wave Form', for example. Yet
they are in no way naturalistic and
are often variations on basic geometric
forms, such as the cylinder and
rectangular block. Many have a thin,
rectangular, slab form, from the surface
of which swell flat-topped ridges. The
ridges often divide the slab into a cross.
The studies show that Adams had
religious imagery in mind when he
drew them, for example on one folio an
abstracted hand is transfixed by a nail
to the arm of a cross, but the forms
have become ambiguous in the final
bronze sculptures. The ridges could be
branching trees, or folds in landscape

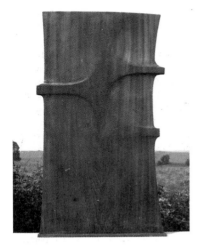

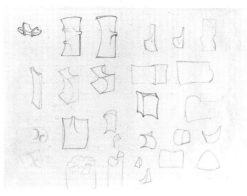

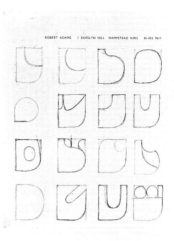

'Slim Mahogany' (cast as 'Slim Bronze No.4',
G.604), 1971 Mahogany 73.7 × 43.2
(29 × 17) *Gimpel Fils Gallery* (G.597)

Studies for sculptures in bronze or stainless
steel, 1971–3
TGA 8421.1.52, f.15

Sixteen studies related to stainless steel
'Vertex' series, 1971, on laid-in writing paper
TGA 8421.1.52, f.18

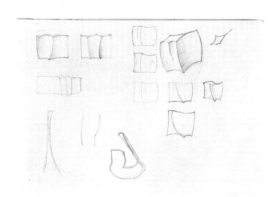

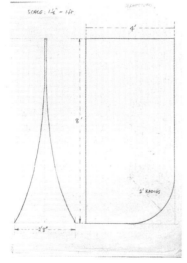

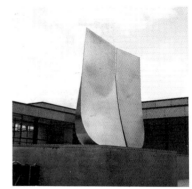

Studies for bronze 'Wave Form' series, 1972–3
TGA 8421.1.52, f.21

Elevations for flank and back of 'Vertex
No.1', 1971
TGA 8421.1.52, f.23

'Phoenix', 1972 Stainless steel 25.4 × 25.4
(10 × 10) *Fire Service Technical College,
Moreton-in-Marsh, Gloucestershire* (G.607)

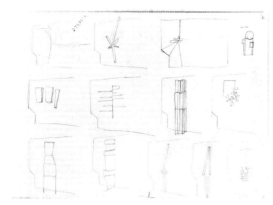

Studies for wall sculpture for unidentified architechural commission, c.1970
TGA 8421.1.52, f.42

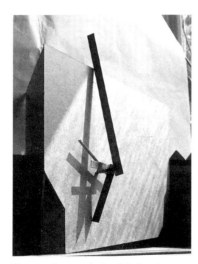

Maquette for unrealised architechural commission, possibly in Rochester, New York ?1970
Stainless steel *Untraced* (G.575)

or gathering waves. The studies are finely drawn in pencil, small-scale, delicately shaded and give a good sense of the size and surface texture of the intended sculptures.

The series of large, polished, stainless-steel sculptures titled 'Vertex' have similar, though more simplified, forms to the contemporary bronzes. 'Vertex No.1', 8 feet high by 4 feet wide, was designed in 1971. It was followed by 'Vertex No.2', of a similar size and a variation on 'No.2', appropriately titled 'Phoenix', made for a new Fire Service Technical College in Gloucestershire. (See W.J. Strachan, *Open Air Sculpture in Britain*, Nos.25, 93, 207.) All were made by professional sheet-metal workers to Adams's specifications and were intended for outdoor sites. They resemble the truncated bows of a ship, cut off so that the height equals twice the width, with flared sides, a flat back and a rounded lower corner at their leading edge. The studies for them show Adams experimenting by removing curved segments from a series of basic, rectangular outlines. Trials with the proportions of height to width and with the radius of the curved corner were carried further in small card maquettes, some of which are in the Tate Gallery Archive (TGA 8421.3.1–8421.3.4, below). Final drawings, probably made for the fabricators, have deceptively simple outlines showing the radius of the curved lower corner and the flaring sides. Studies for the version titled 'Phoenix' begin with schematic drawings of a bird with up-raised wings which is transformed in subsequent studies to a double flame. Allusions to a flame are retained in the final work, which consists of two versions of 'Vertex No.2' placed back to back.

There are a group of studies in this sketchbook for what was obviously an important architectural commission which has not been identified. They all show a prow-like building with a large, blank wall, a corner cut away at ground level and a flat roof. On the blank wall, Adams experimented with many variations of steel sculptures, some of which extended over the roof and down the other side of the building. He must have settled for two possibilities, for photographs survive of two different maquettes (private archive). One has a cluster of long, rectangular planes thrown out asymmetrically from a single point, the other has long planes of equal length, resembling three-pronged forks, which reach towards each other. The probable, though not certain, date of the photographs is the spring of 1970, they are stamped on the back with Adams's Rosslyn Hill address, where he lived in 1969–71, and are included in a folder of negatives dated 14 May 1970. In April 1970 Adams is described as working on a commission 'for Rochester, New York – to relate to a plain brick wall, 54 feet high and 82 feet long'. This was intended to be in stainless steel, but the commission does not seem to have been realised. See I. Mayes, *Northampton Chronicle and Echo*, 8 April 1970.

'Folding Movement' sketchbook, 1972–6

Pencil, ink, coloured wash, felt tip and crayon on white paper: 41 sheets, many loose and laid-in
42 × 29.5 (16½ × 11¾)
Black cover, printed in white: DALER LAY-OUT PAD A3
TGA 8421.1.53

The majority of studies in this sketchbook, which is difficult to date exactly, were probably made in the first half of the 1970s. Among them are a series of finished studies of waves, drawn in black ink or pencil. They are exciting studies. The wave's crest is isolated within a rectangular border. Surging movement is suggested by linear contours. The curving form within the border is controlled, yet full of energy. These studies can be connected with the series of five 'Wave Form' bronzes of 1972–3. Waves seem an improbable subject for sculpture but these studies show Adams's ability to extract the essence of the wave's rhythmic, curving surge; movement had always fascinated him, some of his early sculptures were of a dancer. Adjacent studies for the sculptures of wave forms carry the abstracting process further. The sculptures remain as blocks or slabs, with flat bases and tops. Their flanks are pulled and folded to create rhythmic curves running from top to bottom.

This sketchbook also contains several studies in colour (felt tip) for lithographs and possibly wall-hangings. According to Dr Michael Morris, some studies resemble a screen form lithograph, published by the Penwith Galleries in 1973 (see Tate Gallery P06005), with black vertical lines in stacked rows progressing against colours changing from yellow, through orange to red-brown. Others cannot be related to known lithographs

and may possibly be for intended wall-hangings. Their compositions relate closely to bronzes of 1972–3: the series of wave forms and slim bronzes which have compositions like a branching tree or cross. Close to them are studies for different types of Christian cross, including careful drawings of 'The Thorns', a religious sculpture made by Adams in 1958. One of these drawings shows 'The Thorns' placed in a Gothic church. Mary Adams Weatherhead believes that this group was probably made for a competition to provide a cross for St George's Chapel, Windsor Castle. According to Dr Eileen Scarff, the Chapel archivist, the competition was held in 1973–4.

There are other studies which also take up ideas of many years before, among them studies for the large relief 'Folding Movement'. Adams had first made a maquette of this in 1965, but he was only able to realise it on a large scale ten years later in 1975, when he was commissioned by Misha Black of the Design Research Unit to provide a relief for the remodelled banking hall of Williams & Glyn's Bank in Lombard Street, London. It has since been removed, and was resited in 1990 at Homerton Hospital, London E9. The hall was clad in regular slabs of light travertine. 'Folding Movement' was planned to contrast with this interior, for it is made of dark, bronzed steel plates which are joined in irregular ridges and folds, suggesting organic growth. Studies for it are placed with a variety of other possibilities for the site which was a long wall beneath a low ceiling. All are built up from plates of different sizes expanding in horizontal movement across the folio.

Studies for bronze 'Wave Form' series
TGA 8421.1.53, f.1

Drawings of waves and studies for bronze sculptures of c.1972
TGA 8421.1.53, f.2

'Wave Form No.3', 1973 Bronze
21.2 × 67.3 × 7.6 (8½ × 26½ × 3)
Ed. of 6 + 0 (G.616)

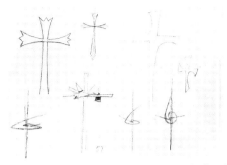

Studies of crosses, probably made for St George's Chapel, Windsor Castle, c.1973
TGA 8421.1.53, f.16

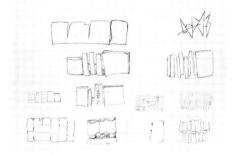

Studies for 'Folding Movement' and other projected reliefs
TGA 8421.1.53, f.22

Drawings of waves, and outline of magnolia flower
TGA 8421.1.53, f.25

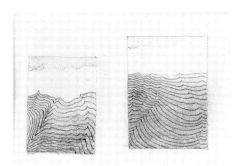

Drawings of waves
TGA 8421.1.54, f.2

Studies for the bronzes 'Pierced Forms' and 'Eclipse', 1975
TGA 8421.1.54, f.6

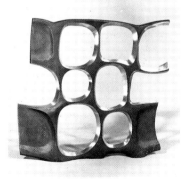

'Pierced Bronze Form No.1', 1975 Bronze
27.9 × 31.7 × 3.8 (11 × 12½ × 1½)
Ed. of 6 + 0 (G.637)

Bronzes, Wall-Hangings sketchbook, 1974–5

Pencil, coloured chalks and ink on thin white paper: 40 sheets
21.2 × 14.6 (8¼ × 5⅞)
Black cover, printed in white: DALER LAY-OUT PAD A5
TGA 8421.1.54

This small sketchbook shows Adams attempting to diversify his work. There are a few studies for executed sculptures of 1974–5, a design for a low table and many coloured studies for wall-hangings. Two folios at the start continue the fine series of finished drawings of waves from the previous sketchbook, TGA 8421.1.53, above. With them is a folio of studies for two further sculptures in the 'Wave Form' series of bronzes ('No.6', 'No.7', 1974, Gimpel Fils). In these the back and trough of the wave have been abstracted to two juxtaposed, L-shaped blocks of different size which curl up to meet each other. There is also a page of studies for the relief 'Folding Movement' for Williams & Glyn's Bank (see the previous entry, TGA 8421.1.53), with forms close to the finished sculpture. And there are studies for the bronzes of 1975, 'Eclipse', 'Pierced Form No.1' and 'Pierced Form No.2' (casts at Gimpel Fils and in private collections). The last two are amongst Adams's most successful bronzes. They have open, cellular structures, again resembling organic forms such as seedpods or honeycombs, and appear capable of further growth. By this date Adams was distinguishing different parts of his sculptures by varying surface textures and patinations. This is suggested by shading in the studies.

The majority of studies in this sketchbook are for wall-hangings. As far as it is known, only one hanging by Adams was woven, in 1975, and it

is untraced. It has a composition of rectangular forms coloured black, red and yellow, which tilt and balance asymmetrically. There are studies for it here and for many others which do not seem to have been executed, although according to Mary Adams Weatherhead, her father carried out experiments with weaving himself while in Cornwall in the mid-1970s. The studies are usually drawn two to a page in coloured chalks. Some have compositions abstracted from natural forms such as leaves, tree trunks, flowers. Others have basic geometric forms, rectangular or circular, which move around an axis dividing the rectangular format of the whole (see TGA 8421.1.55, below).

Studies for 'Folding Movement' for Williams & Glyn's Bank, 1975–6
TGA 8421.1.54, f.11

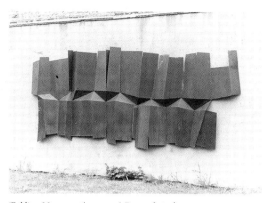

'Folding Movement', 1975–6 Bronzed steel
198.1 × 487.7 ×19 (78 × 192 × 7½) (G.639)
Designed for Williams & Glyn's Bank, 67 Lombard St, London EC 3. Removed and resited at Homerton Hospital E 9 in 1990

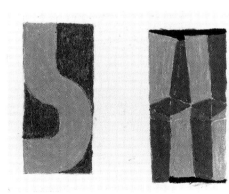

Studies for wall-hangings
TGA 8421.1.54, f.16

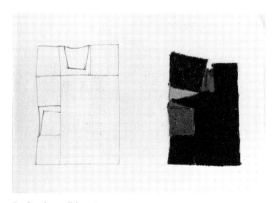

Studies for wall-hangings
TGA 8421.1.54, f.40

Design, perhaps for wall-hanging, with forms
resembling 1970 weathervane
TGA 8421.1.55, f.1

Wall-Hangings, studies, *c.*1974–5

Pencil and coloured crayons on thin
white paper: 4 loose sheets
sheet 1, 14.2 × 28.6 (5¾ × 11¼);
sheets 2, 3, 28.6 × 29.7 (11¼ × 11⁹⁄₁₆);
sheet 4, 30.8 × 28.6 (12½ × 11¾)
TGA 8421.1.55, ff.1–4

These six compositions in coloured
crayons on four, larger, loose sheets
of paper, were also probably intended
for hangings. Two of them have
symmetrical, centralised compositions,
with leaf-like forms, similar to that of
a weathervane designed by Adams in
1970, flowing towards each other. The
compositions of the four others, drawn
two to a sheet, move from top to
bottom through a colour shift passing
from orange/pink to green/blue. The
change perhaps evokes the passing
seasons. The forms are not realistic,
but they do suggest leaves or blossom
or pebbles (see also TGA 8421.1.54,
above.)

Rectangular Space study, 1970s

Pencil on writing paper: single sheet
Printed on the verso: Patricia
Adams/RANGERS HALL, GREAT
MAPLESTEAD, Nr HALSTEAD,
ESSEX/HEDINGHAM 142
25.2 × 20.3 (10 × 8)
TGA 8421.1.56

Fifteen Rectangular studies, 1970s

Pencil and blue ink on white paper:
single sheet
29.8 × 21.2 (11¾ × 8⁵⁄₁₆)
TGA 8421.1.57

Outline study, 1970s

Light blue ink on writing paper:
single sheet
25.2 × 20.3 (10 × 8)
TGA 8421.1.58

Flower-head study, 1970s

Blue ballpoint and puce ink wash on
white card: single sheet
6.9 × 14 (2¾ × 5½)
Signed 'Robert Adams' bottom right
TGA 8421.1.59

'Two', an Elevation sketchbook, 1976–7

Pencil on white paper: 1 drawn page only
42 × 29.7 (16½ × 11¾)
Black cover, printed in white: DALER LAY-OUT PAD A3
TGA 8421.1.60

This sketchbook contains only one drawn folio, though it is possible that another folio with a drawing of the same subject has been removed from it and inserted in TGA 8421.1.53, f.33, above.

The drawing is an elevation for the stainless-steel sculpture titled 'Two', from the front and the side. It was probably drawn for the firm of professional sheet-metal workers who made the sculpture, as it is inscribed with instructions and exact measurements. Similar drawings exist for 'Vertex' and 'Crescent Edge', which were also made by a specialist firm to Adams's specifications. 'Two' is made from two sheets of stainless steel, 8 × 4 feet, mounted back to back and bent slightly away from each other from their midpoints. The tops of the sheets are straight but their bottom corners curl outwards. 'Two' was exhibited at the *Silver Jubilee Exhibition of Contemporary British Sculpture* in Battersea Park, London, in 1977.

There is a marked difference between Adams's small bronzes and his large stainless-steel sculptures of the 1970s. The bronzes have subtle changes in contour and texture and were intended for intimate viewing. The stainless-steel sculptures are for public display. Their forms are large and simple and their surfaces reflect their surroundings.

Elevations of 'Two', inscribed with instructions and measurements, 1976–7
TGA 8421.1.60, f.1

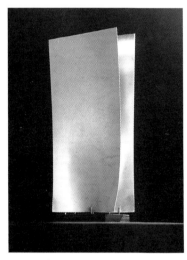

Maquette for 'Two', 1976–7 Aluminium 54 (21¼) *Gimpel Fils Gallery* (G.645)

Round sketchbook, 1980

Pencil on white paper pierced with punched hole: 18 sheets
8.9 (3½) diameter
TGA 8421.1.61

This series of small, round leaves makes up one of Adams's last surviving sketchbooks. It contains studies for his last bronze sculptures of 1980–1, some of the 'Ovoid Variations', 'Crest', 'Pterinea Form' and 'Divergence 2', which were not exhibited publicly during his lifetime. The delicate pencil studies relate well to the sculptures, many of which are enclosed ovals containing smaller ovals, like the beds of seeds within fruit. Significantly, there is a small sketch of an apple on the verso of one of the leaves.

In the studies the oval areas are darkly shaded, while in the bronzes they are distinguished by gritty texture and grey/brown patination. The remainder of the surface is a smooth brown colour, with points of growth more highly polished. In all the late sculptures there are suggestions of growth within an enclosing womb or of buds and shoots emerging from a bulbous core. Most are rather flat, occupying a shallow layer of space, but within this layer changes in contour and direction are very subtle.

Study for bronze 'Ovoid Variation No.6 (Peacock)', 1980
TGA 8421.1.61, no.5

Squared-up study for intended bronze
TGA 8421.1.61, no.16

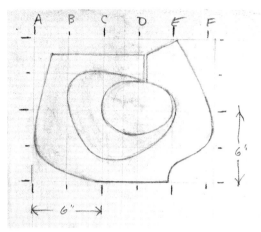

Squared-up study, inscribed with
measurements and letters, for top of bronze
'Centurion', c.1981
TGA 8421.1.62, f.10

Late Bronzes sketchbook,
1980–1

Pencil on white paper: 21 loose sheets
Various sizes
TGA 8421.1.62

Probably dating from the same time as
the studies on the small, circular sheets
listed above, are studies on twenty-one
small sheets of rectangular paper of
various sizes. Among them are studies
for the bronzes 'Pterinea Form', 'Crest'
and the 'Ovoid Variations' and for two
further bronzes Adams made on
commission for Christie's in 1981–2,
titled 'Semaphore' and 'Centurion'. Like
his other late bronzes, these sculptures
for Christie's have flat, round edged,
forms, suggesting bulbs or flowerheads,
which are raised up on slim stalks.

Base and Fixings study [n.d.]

Pencil and blue ballpoint on cream
paper: single sheet
10 × 16.4 (4 × 6½)
Inscribed: 5" × 4" × 6"/DIA
BOLTS/PLATE ⅜"/BOLTS 7" x/2% off
TGA 8421.1.63

Two Stalks study [n.d.]

Blue ballpoint on white paper:
single sheet
20.7 × 14.6 (8¼ × 5¾)
TGA 8421.1.64

This rough study shows a stalk-like
construction with two knobs raised
on two uprights.

Loopline, two studies [n.d.]

Black ink on thin white paper: 2 sheets
25.3 × 20.2 (10 × 8)
TGA 8421.1.65, 8421.1.66

Rocking-Horse, two studies,
c.1978

Pencil and red ballpoint on thin white
paper: 2 sheets
TGA 8421.1.67: 21.2 × 20.8 (8¼ × 7)
TGA 8421.1.68: 21.1 × 8.2 (8½ × 3⅛)
Measurements inscribed
TGA 8421.1.67, 8421.1.68

Adams made a wooden rocking-horse
c.1978 which is in a private collection.
TGA 8421.1.67 shows a squared-up
side view and TGA 8421.1.68 shows a
squared-up front view.

Records of Work

The following series are written and drawn records of work to be exhibited, for catalogues, etc.

TGA 8421.1.69 – 8421.1.79

Venice Biennale, 1962

Pencil and blue ballpoint on white writing paper: single sheet
25.2 × 20.1 (10 × 8)
Inscribed middle top: Chester Beatty
TGA 8421.1.69, ff.1, 2.

This sheet shows written descriptions with rough drawings of twenty-nine sculptures for exhibition at the 1962 Venice Biennale.

Gimpel Fils, November 1962

Pencil and blue ballpoint on white writing paper: 2 sheets
25.2 × 20.1 (10 × 8)
TGA 8421.1.70

This sheet shows written descriptions with rough drawings of thirty-six sculptures, eight maquettes and four lithographs for exhibition at Gimpel Fils Gallery in November 1962.

Record of Work 1, 1965–6

Blue ink and ballpoint on white paper: single sheet
25.2 × 20.1 (10 × 8)
TGA 8421.1.71

Six drawings, in pencil and black ballpoint, of sculptures of 1965 in bronzed steel titled 'Vertical Form No.1', 'Vertical Form No.2', 'Vertical Form No.3'.

Record of Work 2, 1965–6

Pencil on white paper: single sheet
44.2 × 27.8 (17¼ × 11)
TGA 8421.1.72

Outline drawings of nine sculptures of 1965. The sheet is divided into rectangular compartments. Beside each drawing are given the material, height, date and, in most cases, title, of the sculpture.

Record of Work 3, 1976

Pencil and blue ballpoint on white paper (folded): single sheet
20.2 × 12.5 (8 × 5)
TGA 8421.1.73

Details and drawings of two bronze sculptures of 1976 for a catalogue. The sculptures are 'Reclining Form (Thorns), Opus 374', and 'Twin Forms, Opus 373'.

Record of Work 4, 1977

Pencil and blue ballpoint on white paper, folded: single sheet
14.9 × 10.9 (5⅞ × 4¼) irregular
TGA 8421.1.74

Descriptions of three sculptures of 1977 for a catalogue. 'Two, Opus 376'; 'Split Forms [Opus 381]', 'Opus 379' (crossed out); 'Brown Wing, Opus 378'.

Record of Work 5, 1977

Black ballpoint on white paper: single sheet
17.7 × 13.9 (7 × 5½)
TGA 8421.1.75

Written description and rough drawings of four early sculptures for an exhibition of *Art from Cornwall, 1945–55*, at the New Art Centre, London, 1977. Adams does not seem to have shown work in this exhibition.

Record of Work 6, 1978

Pencil and blue ballpoint on white paper
14.9 × 15.4 (5¾ × 6)
TGA 8421.1.76

Pencil drawings, probably for the foundry, for five bronze sculptures of 1978. Inscribed at top: 'Ordered Oct 1978'. Drawings of the sculptures with Opus numbers.

Record of Work 7, 1980

Pencil on lined white paper folded in three: a single sheet
10.2 × 16.5 (4 × 6½)
TGA 8421.1.77

Recto: descriptions and rough drawings for three bronze sculptures of 1980, for a catalogue; 'Cryptic Form No.1, Opus 393'; 'Cryptic Form No.2, Opus 394'; 'Two Curving Forms, Opus 395'. Verso: pencil titles for sculptures: 'Curvilinear', 'Cuniform', 'Cryptic Form', 'Form with Curves'.

Record of Work 8, 1980

Pencil, blue ballpoint and black ink on white paper: a single sheet
13 × 21 (5 × 8⅛)
TGA 8421.1.78

Written description and rough drawings of three bronze sculptures, including 'Cryptic Form No.2, Opus 394'; 'Shell Form, Opus 396'; 'Ovoid Variation No.1, Opus 397'.

Record of Work 9, May 1982

Ballpoint and ink on white paper: single sheet
20.9 × 11.7 (8¼ × 4¾)
TGA 8421.1.79

Written description of five sculptures 1955–81 for a catalogue; annotated with prices and inscribed: 'Works shown at Goethe Institute May 82, then on to Edinburgh'.

Collages

TGA 8421.2.1 – 8421.2.7

Collage Two [n.d]
TGA 8421.2.2
See also cover illustration

Collage One [n.d.]

Segments of circles and rectanglar slips of grey, black, and yellow coloured paper mounted on card
25.2 × 36.2 (10½ × 14¼)
Inscribed 'No.36'
TGA 8421.2.1

Collage Two [n.d.]

Segments of circles and rectangular slips of grey, black, red and white coloured card
24.7 × 35.4 (9¾ × 14)
Inscribed 'No.37'
TGA 8421.2.2

Collage Three (unfinished) [n.d.]

Nine dark coloured, loose sheets of cut paper and a hardboard panel
29 × 29 (11⅝ × 11⅝)
TGA 8421.2.3

Collage Four [n.d.]

Rectangles of brown, blue, black, red, green coloured paper mounted on hardboard panel, mounted on a grey card
37.6 × 13.5 (14¹³⁄₁₆ × 5⅜)
TGA 8421.2.4

Collage Five [n.d.]

Black, maroon, yellow and brown pieces of coloured paper mounted on a hardboard panel
29 × 29 (11⅜ × 11⅜)
TGA 8421.2.5

Collage Six [n.d.]

Red, green, black, maroon and grey pieces of coloured paper mounted on hardboard panel
29 × 29 (11⅜ × 11⅜)
TGA 8421.2.6

Collage Seven [n.d.]

Black, maroon, grey, blue and red pieces of coloured paper mounted on hardboard panel on grey card
Panel size 24 × 24 (9⁷⁄₁₆ × 9)
TGA 8421.2.7

When he developed from abstraction to constructed abstract art in the early 1950s, Adams shared with his painter friends Victor Pasmore, Anthony Hill, Terry Frost and others, an interest in collage. They cut 'self-coloured' papers into basic shapes, triangle, semi-circle, rectangle, and with them built up compositions with constructed movement. Sometimes systems of proportion, such as the golden section, derived from theoreticians like Hambidge or Ghyka, were used. Adams showed twelve, unspecified, collages at Gimpel Fils in March 1953 (nos.21–32) and

early in 1955 he showed two more at the exhibition *Nine Abstract Artists* which have been identified with some certainty (Nos.4, 5, 'Moving Forms', 'Descending Forms', private collection). These two are composed of segments of circles, cut from coloured papers, which are tilted and rocked in relation to each other so that they form an apparently natural progression, like a shoal of leaves, across and down the sheet. He continued occasionally to work in collage and he last exhibited collages in a one-man exhibition in 1978 held at Gainsborough's House, Sudbury (Nos.20–3).

Among a group of small, fragmentary, loose sheets of drawings (TGA 8421.1.20–8421.1.29, above) in the Tate Gallery Archive are studies which relate to the two collages shown at *Nine Abstract Artists*. On one of these sheets (TGA 8421.1.29) are studies for two of the undated collages in the Archive (TGA 8421.2.1 and 8421.2.2). These two are made from long, thin segments of circles, and rectangular slips, cut from card coloured grey, yellow, red, black and white. The pieces are numbered beneath. They were not tilted but were mounted vertically, in a horizontal block measuring about 10 × 15 inches, so that the curves mirror each other and contrast with the straight edges. The small studies show the care Adams took to establish a rhythm across the composition. The supports of these collages have been pinned up and are inscribed with numbers in their corners, so they were probably exhibited but when and where is unknown.

The other five collages, also undated, have hardboard supports. Four of the panels are square, measuring about 11 × 11 inches, the fifth is about three times as high as it is long (TGA 8421.2.4, 14⅞ × 5⅛ inches). One of the square panels (TGA 8421.2.3) was probably never made up as a completed collage. Two pencil lines are ruled across it and with it are nine loose pieces of paper, cut into geometric shapes, from pages of a book or magazine, chosen for their very dark, glossy surface. The other panels are stuck over with rectangular pieces of self-coloured papers, brown, blue, red, green, black, maroon, yellow, grey. Their compositions are totally abstract and in this way, with their rectangular forms, are closer to the collages of Jean Arp and Sophie Taeuber made in 1918 than to those of the Cubists of *c*.1912. Their date is uncertain. Possibly they are from the group of collages shown at Gimpel Fils in 1953. A linocut dated 1952 has a related composition, with rectangles divided by clear, thin, straight, lines (see F. Carey and A. Griffiths, *Avant-garde British Printmaking 1914–60*, British Museum 1990, no.188, col. pl.).

Maquettes and Three-Dimensional Objects

TGA 8421.3.1 – 8421.3.15

White card maquettes for 'Vertex No.1'
TGA 8421.3.1, 8421.3.2

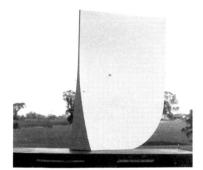

Maquette for 'Vertex 1', 1971 Wood
29.8 × 22.2 (11¾ × 8¾) *Untraced* (G.600)

Four card maquettes for the 'Vertex' series of 1971–2 (TGA 8421.3.1–8421.3.4)

Maquette for 'Vertex No.1', 1971–2

White card
20.4 × 10.2 5.1 (8 × 4 × 2)
TGA 8421.3.1

Maquette for 'Vertex No.1', 1971–2

White card
17.7 × 10.2 × 5.4 (7 × 4 × 2¼)
Inscribed at bottom left: 1" = 1'
TGA 8421.3.2

Maquette for 'Vertex No.2', 1971 or 'Phoenix', 1972

White card
15.2 × 12.5 × 5.4 (6 × 5 × 2¼)
Inscribed at bottom left: 1" = 1'
TGA 8421.3.3

Maquette Related to 'Vertex' Series, 1971–2

White card
15.2 × 15.2 × 15.2 (6 × 6 × 2½)
Inscribed inside: 1" = 1 ft
TGA 8421.3.4

As mentioned in the entry for the *Vertex* sketchbook (TGA 8421.1.52, above), in 1971–2, Adams designed a group of large sculptures in stainless steel titled 'Vertex', for outdoor sites adjacent to modern buildings. 'Vertex No.1' (8 ft × 4 ft × 32 in) was sited outside the Kingswell Development, Heath Street, Hampstead. A copy of 'Vertex No.2', which was made in an edition of three and is of similar size to 'No.1', is placed in Mobil Court, Clements Inn, London WC2. A modification of 'Vertex No.2', titled 'Phoenix', consisting of two sculptures placed back to back, and measuring 10 × 10 feet, is outside the Fire Service Technical College, in Moreton-in-Marsh, Gloucestershire. All these stainless steel sculptures were made by the steel fabricating firm of Horner and Wells in Chelmsford under Adams's supervision. He made hardwood patterns to scale for the firm to work from and these were preceded by the drawings and card maquettes in the Tate Gallery Archive.

It does not seem to have been Adams's standard practice to make maquettes for his sculptures, although he did so on several occasions and other maquettes are known, especially for sculptures of 1968.

Maquette Related to 'Chasm' and 'Fissure', c.1972

Card
10 × 5 × 4.3 (4 × 2 × 1⁵⁄₁₆)
TGA 8421.3.5

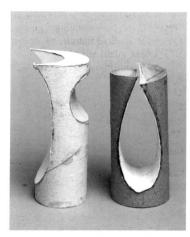

Card maquettes related to bronzes 'Chasm', 'Fissure', 'Cavetto No.1' and 'No.2'
TGA 8421.3.5, 8421.3.6

Documents and Self-Portrait

Correspondence
TGA 8421.4.1 –
8421.4.179

Much of this correspondence is connected with Adams's work as a sculptor. There are letters from potential buyers offering commissions or seeking to purchase works, and from museums and galleries about loans for exhibition. There is correspondence from publishers, mainly requesting photographs of works. There are offers of teaching commissions, invitations to lecture or judge competitions, letters about studio equipment or technical processes used by Adams, appeals for studio work-experience by students and negotiations for selling and leasing houses and studios. There are also a number of personal notes from friends offering congratulations on his marriage and wishing luck for exhibitions. The correspondence also includes a small number of draft replies written by Robert Adams.

Personal Papers
TGA 8421.5.1 –
8421.5.75

Manuscripts and Writings

TGA 8421.5.1–8421.5.11
Manuscripts and writings by Robert Adams, including notes for students

TGA 8421.5.12–8421.5.14
Writings about Robert Adams by other authors

Financial Records

TGA 8421.5.15–8421.5.22
Banking and savings books

TGA 8421.5.23–8421.5.31
Tax and National Insurance papers

TGA 8421.5.32–8421.5.53
Bills, accounts and receipts

Official Documents

TGA 8421.5.54–8421.5.56
Medical card, passport, motor insurance

Printed Material

TGA 8421.5.57–8421.5.60
Exhibition catalogues

TGA 8421.5.61–8421.5.63
Private view cards

TGA 8421.5.64–8421.5.75
Other printed booklets, etc.

Photographs
TGA 8421.6.1 – 61

TGA 8421.6.1–8421.6.19
Photographs of works of art by Robert Adams, 1950–77

TGA 8421.6.20–8421.6.61
Personal photographs, 1928–69

Presscuttings
TGA 8421.7

Self-Portrait, c.1946
TGA 8421.8

Oil on textured paper
36.8 × 27.5 (14½ × 10⅞)

See frontispiece.

Chronology

1917
5 October: Born in Northampton, son of a gardener.

c.1937–c.1946
Attends evening classes, part-time, in life-drawing and painting at Northampton School of Art. Conscientious objector during Second World War. Works in printing shop, timber yard and for a firm of agricultural machinery makers.

1946–7
Lives on savings and devotes himself full-time to sculpture.
November 1947–January 1948: First one-man exhibition at Gimpel Fils Gallery, London.

1948
Spends several weeks in Paris, taken to visit Brancusi, Laurens and other artists by Maxime Adam-Tessier.

1949
Starts to teach at the Central School of Art, London. Continues to teach there until 1961. April: one-man exhibition, Gimpel Fils Gallery. June: one-man exhibition, Galerie Jeanne Bucher, Paris. Autumn: elected to London Group.

1950
'Boy with owl' in reinforced concrete, Kings Heath Lower School, Northampton. September-December: visits New York and Chicago.

1951
'Apocalyptic Figure' commissioned from the Arts Council for the Festival of Britain. July: one-man exhibition, Gimpel Fils Gallery. August: marries Patricia Devine. Moves to London. At about this time becomes a Roman Catholic.

1952
June–October: exhibits in *New Aspects of British Sculpture*, XXVI Biennale, Venice. Makes first of regular visits to St Ives, Cornwall.

1953
March–April: one-man exhibition, Gimpel Fils Gallery.

1954–5
Contributes to the book *Nine Abstract Artists* (ed. L. Alloway) and the exhibition of the same title, Redfern Gallery.

1956
February: one-man exhibition, Gimpel Fils Gallery. August–September: pavilion at *This is Tomorrow* exhibition, Whitechapel Art Gallery, London, with Colin St John Wilson, Frank Newby, Peter Carter. Steel fountain for Sconce Hills School, Newark-on-Trent.

1957
April–May: one-man exhibition, Galerie Parnass, Wuppertal, West Germany, subsequently toured. August: competes successfully to provide a large relief for the new Municipal Theatre at Gelsenkirchen, West Germany, completed 1959. Relief for Eltham Green School, London SE9.

1958
February–March: one-man exhibition, Gimpel Fils Gallery. June: commissioned for a relief for Queen's Gardens, Hull, completed 1960.

1960
September: one-man exhibition, Gimpel Fils Gallery.

1961
Retrospective exhibition, Ferens Art Gallery, Hull and the Hatton Gallery, Newcastle-upon-Tyne. Ceiling, wall-relief for P&O liner, *S.S. Canberra*.

1962
Summer: retrospective exhibition British Pavilion, XXXI Biennale, Venice, subsequently toured. November: one-man exhibition, Gimpel Fils Gallery.

1963
March–April: one-man exhibition, Bertha Schaefer Gallery, New York. Visit to USA. 25 July: birth of daughter, Mary. Sculpture installed on facade at 24 Cathcart Road, London SW10.

1964
Bronze gate for Mr and Mrs James Clark, Dallas. Altarpiece for St Louis Priory, Missouri. Screens for Sekers Textile Showrooms, Sloane Street, London SW1.

1966
October: one-man exhibition, Gimpel Fils Gallery. Nine feet diameter bronzed steel roundel for British Petroleum, Moor Lane, London EC 2.

1967
Steel screens for New Custom House, Heathrow Airport.

1968
February–March: one-man exhibition, Bertha Schaefer Gallery, New York. Steel sculpture, School of Mathematical Sciences, Queen Mary College, London E 1. September: one-man exhibition, Gimpel Fils Gallery.

1971
January–July: retrospective exhibition starting at City Art Gallery, Northampton and touring to Sheffield, Newcastle-upon-Tyne and Camden Art Centre, London. Spring: moves from London to Great Maplestead, Essex.

1972
'Vertex No. 1', Kingswell Centre, Hampstead. 'Phoenix', Fire Service Technical College, Gloucestershire.

1974
May–June: one-man exhibition, Gimpel Fils Gallery.

1975–6
Lives in St Ives, Cornwall, but retains Essex home. 'Folding Movement', Williams & Glyn's Bank, Lombard Street, London EC 3.

1978
July: one-man exhibition, Gainsborough's House, Sudbury, Suffolk.

1979
October–November: one-man exhibition, Gimpel Fils Gallery.

1980
November–January 1981: one-man exhibition, Gimpel-Hanover Gallery, Zurich.

1981
March–April: one-man exhibition, Lister Gallery, Perth, Australia. April–May: one-man exhibition, Gimpel and Weitzenhoffer, New York.

1984
5 April: dies at Great Maplestead, Essex.

Bibliography

This select bibliography excludes one-man exhibitions, which are listed in the Chronology. References to individual works by the artist will also be found in the catalogues of the collections of the Arts Council, the British Council, the Tate Gallery, and the Albright Knox Gallery, Buffalo.

Adams, Robert. Personal statement. *Ark*, no.19, March 1957, pp.28–9.

Alloway, L. (ed.). *Nine abstract artists.* London: A. Tiranti, 1954.

Blakeston, O. Profile of Robert Adams. *Arts Review*, vol.23, no.13, 3 July 1971, p.405.

Chew, P.A. Robert Adams: abstract sculptor, *224* (University of Manchester), no.6, 1956, pp.21–2.

Curtis, P. *Modern British sculpture from the collection.* London: Tate Gallery, 1988. Published for the display at the Tate Gallery Liverpool, from Sept. 1988.

Farr, D. *British sculpture since 1945.* London: Tate Gallery, 1965.

Grieve, A. Robert Adams. *Art Monthly*, no.121, November 1988, pp.77–8.

Grieve, A. *The Sculpture of Robert Adams.* London: Lund Humphries and the Henry Moore Foundation, 1992.

Hall, H.B. British sculpture: Adams and Chadwick. *Bulletin, University of Michigan, Museum of Art, Ann Arbor*, no.6, May 1955, pp.11–14.

Hazan, F. *Dictionnaire de la sculpture moderne.* Paris: Hazan, 1960.

Hillman, N. *Robert Adams: a critical study and complete catalogue.* Unpublished dissertation, Institute of Fine Arts, New York University, 1969.

Lewis, D. Robert Adams. *Architectural Design*, vol.28, no.3, March 1958, p.120.

Mayes, I. Robert Adams. *Sculpture International*, vol.2, no.4, April 1969, pp.6–11.

Nairne, S. and N. Serota (eds.). *British sculpture in the twentieth century.* London: Whitechapel Art Gallery, 1981. Published on the occasion of a two-part exhibition at the Whitechapel Art Gallery 1981–2.

Ramsden, E.H. *Twentieth century sculpture.* London: Pleiades Books, 1949.

Read, H. *A concise history of modern sculpture.* London: Thames and Hudson, 1964.

Robertson, B., J. Russell and Lord Snowdon. *Private view.* London: Nelson, 1965.

Seuphor, M. *The sculpture of this century.* London: A. Zwemmer, 1959.

Spencer, C. Profile of Robert Adams. *Arts Review*, vol.18, no.16, 20 Aug. 1966, pp.384–5.

Strachan, W.J. *Open air sculpture in Britain.* London: A. Zwemmer and Tate Gallery, 1984.

Thackray, F.E. *Robert Adams: his development and characteristics as a sculptor and his place amongst his contemporaries in Britain.* Unpublished dissertation, University College of Wales, Aberystwyth University, 1980.

Thwaites, J.A. Der bescheidene Meister: die Plastik von Robert Adams. *Das Kunstwerk*, vol.11, no.9, March 1958, pp.20–4.

Trier, E. *Form and space: the sculpture of the twentieth century.* Rev. ed. London: Thames and Hudson, 1968.

Summary Listing of Contents

Sketchbooks and Studies

Northampton sketchbook 1, c.1944
TGA 8421.1.1 22

'Standing Workman' c.1940-6
TGA 8421.1.2 24

'Self-Portrait', c.1940-6
TGA 8421.1.3 24

Northampton sketchbook 2, c.1944-7
TGA 8421.1.4 24

Northampton sketchbook 3, c.1947
TGA 8421.1.5 25

Northampton/'Paris' sketchbook 1,
c.1947-9
TGA 8421.1.6 26

'Paris' sketchbook 1, c.1948-50
TGA 8421.1.7 28

'Paris' sketchbook 2, c.1949-51
TGA 8421.1.8 30

'Presentation', studies, c.1952-3
TGA 8421.1.9 31

Chairs, studies, ?early 1950s
TGA 8421.1.10-8421.1.14 32

Constructions, Heads, studies, c.1951-4
TGA 8421.1.15-8421.1.17 32

Carving to Welding sketchbook,
c.1952-7
TGA 8421.1.18 33

Judgement and Crucifixion, studies,
1950s
TGA 8421.1.19 36

Prints and Collages studies, 1954-5
TGA 8421.1.20-8421.1.29 36

Gelsenkirchen sketchbook, c.1956-61
(majority c.1957)
TGA 8421.1.30 37

Movement in Metal, studies, c.1958-60
TGA 8421.1.31 41

S.S. Canberra, studies, c.1961-4
TGA 8421.1.32-8421.1.39 41

Cathcart Road sketchbook, c.1963-6
TGA 8421.1.40 43

Screen Forms sketchpad, ?c.1964
TGA 8421.1.41 44

Dallas sketchbook, c.1964-5
TGA 8421.1.42 45

Standing Screen study, c.1964-5
TGA 8421.1.43 45

Gimpels '66 and '68 sketchbook,
c.1965-8
TGA 8421.1.44 46

A Move? sketchbook, 1968 or 1971
TGA 8421.1.45 48

'Straus' Screen study, c.1969
TGA 8421.1.46 48

Marble sketchbook, c.1969-70
TGA 8421.1.47 49

?Flowers study [n.d.]
TGA 8421.1.48 50

Large Marble study, c.1970
TGA 8421.1.49 50

'Marble No.4' working drawing, 1970
TGA 8421.1.50 50

'Marble No.6' study, 1970
TGA 8421.1.51 50

'Vertex' Series sketchbook, 1970-3
TGA 8421.1.52 51

'Folding Movement' sketchbook,
1972-6
TGA 8421.1.53 54

Bronzes, Wall-Hangings sketchbook
1974-5
TGA 8421.1.54 55

Wall-Hangings, studies, c.1974-5
TGA 8421.1.55 57

Rectangular Space study, 1970s
TGA 8421.1.56 57

Fifteen Rectangular studies, 1970s
TGA 8421.1.57 57

Outline study, 1970s
TGA 8421.1.58 57

Flower-head study, 1970s
TGA 8421.1.59 57

'Two', an Elevation sketchbook,
1976-7
TGA 8421.1.60 58

Round sketchbook, 1980
TGA 8421.1.61 58

Late Bronzes sketchbook, 1980-1
TGA 8421.1.62 59

Base and Fringes study [n.d.]
TGA 8421.1.63 59

Two Stalks study [n.d.]
TGA 8421.1.64 59

Loopline, two studies [n.d.]
TGA 8421.1.65, 8421.1.66 59

Rocking-Horse, two studies, c.1978
TGA 8421.1.67, 8421.1.68 59

Records of work

Venice Biennale, 1962
TGA 8421.1.69 60

Gimpel Fils, 1962
TGA 8421.1.70 60

Record of Work 1, 1965–6
TGA 8421.1.71 60

Record of Work 2, 1965–6
TGA 8421.1.72 60

Record of Work 3, 1976
TGA 8421.1.73 60

Record of Work 4, 1977
TGA 8421.1.74 60

Record of Work 5, 1977
TGA 8421.1.75 60

Record of Work 6, 1978
TGA 8421.1.76 60

Record of Work 7, 1980
TGA 8421.1.77 60

Record of Work 8, 1980
TGA 8421.1.78 60

Record of Work 9, 1982
TGA 8421.1.79 60

Collages

Collage One [n.d.]
TGA 8421.2.1 61

Collage Two [n.d.]
TGA 8421.2.2 61

Collage Three (unfinished) [n.d.]
TGA 8421.2.3 61

Collage Four [n.d.]
TGA 8421.2.4 61

Collage Five [n.d.]
TGA 8421.2.5 61

Collage Six [n.d.]
TGA 8421.2.6 61

Collage Seven [n.d.]
TGA 8421.2.7 61

Maquettes and Three-Dimensional Objects

Maquette for 'Vertex No.1', 1971–2
TGA 8421.3.1 63

Maquette for 'Vertex No.1', 1971–2
TGA 8421.3.2 63

Maquette for 'Vertex No.2', 1971 or 'Phoenix', 1972
TGA 8421.3.3 63

Maquette Related to 'Vertex' Series, 1971–2
TGA 8421.3.4 63

Maquette Related to 'Chasm' and 'Fissure', c.1972
TGA 8421.3.5 63

Maquette Related to 'Cavetto Nos. 1 and 2', c.1972–3
TGA 8421.3.6 64

Maquette for Unknown Sculpture [n.d.]
TGA 8421.3.7 64

Dismembered Mobile, c.1951
TGA 8421.3.8 64

Maquette Related to 'Pierced Horizontals', 1959 or for a Brooch, c.1958–60
TGA 8421.3.9 64

Maquette for 'Curving Movement' or 'Horizontal Movement' or a Brooch, c.1958–60
TGA 8421.3.10 65

Maquette for Sculpture, c.1959
TGA 8421.3.11 65

Maquette for Brooch (?), ?c.1964–5
TGA 8421.3.12 65

Embossing Block, 1968
TGA 8421.3.13 65

Two Blades for a Cutting Tool
TGA 8421.3.14, 8421.3.15 65

Documents and Self-Portrait

Correspondence
TGA 8421.4.1–8421.4.179 66

Personal Papers
TGA 8421.5.1–8421.5.75 66

Photographs
TGA 8421.6.1–8421.6.161 66

Presscuttings
TGA 8421.7 66

Self-Portrait, c.1946
TGA 8421.8 66

The Tate Gallery Archive

The Tate Gallery Archive of Twentieth-Century British Art mainly collects original documents that record and illustrate the history of British Art in this century. Material includes sketchbooks, drawings, notebooks, diaries, correspondence, photographs, films, presscuttings, printed ephemera and audio-visual material. The Archive is open to bona fide researchers on Thursdays and Fridays, 10.00 – 13.00 and 14.00 – 17.30, by appointment only, and Archive staff are always pleased to answer telephone and written enquiries.

Other Tate Gallery Archive publications

Portrait of the Artist
David Fraser Jenkins and Sarah Fox-Pitt

In 1982 the Tate Gallery Archive acquired 122 artists' portraits from John Gainsborough who had inherited the collection from his father Richard Gainsborough, founder of Art News and Review. Over one hundred of these self-portraits, published by the magazine between 1949 and 1960, are reproduced.

1989
ISBN 1 85437 007 3 (paper)
ISBN 1 85437 010 3 (cloth)

John Piper: A Painter's Camera
Buildings and Landscapes in Britain
1935–1985
David Fraser Jenkins

Photography was a frequent source of inspiration for John Piper's landscape painting, and a long association with the Shell Guides and the Architectural Review inspired a wealth of images. In 1985, he presented to the Tate Gallery Archive all the negatives still in his possession, amounting to over 5,000 items. The selection of photographs published here was made on the advice of the artist from original negatives, and all but a few were newly printed.

1987
ISBN 0 946590 81 8 (cloth)

Paul Nash's Photographs:
Document and Image
Andrew Causey and Clare Colvin

Paul Nash's photographs were not generally intended as straight records of places and evens but were complementary to his work as a painter. In 1970 the Paul Nash Trust generously presented all his surviving negatives, numbering 1297, to the Tate Gallery Archive, together with the corresponding number of prints.
An introduction by Andrew Causey accompanies a selection of ninety-nine plates.

1973 with 1977 supplement
Out of print
ISBN 0 900874 59 7